The Maritime Paintings of
Robert Taylor

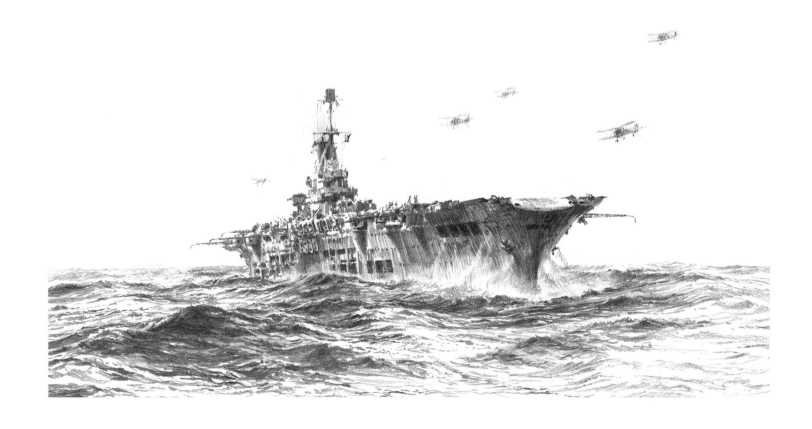

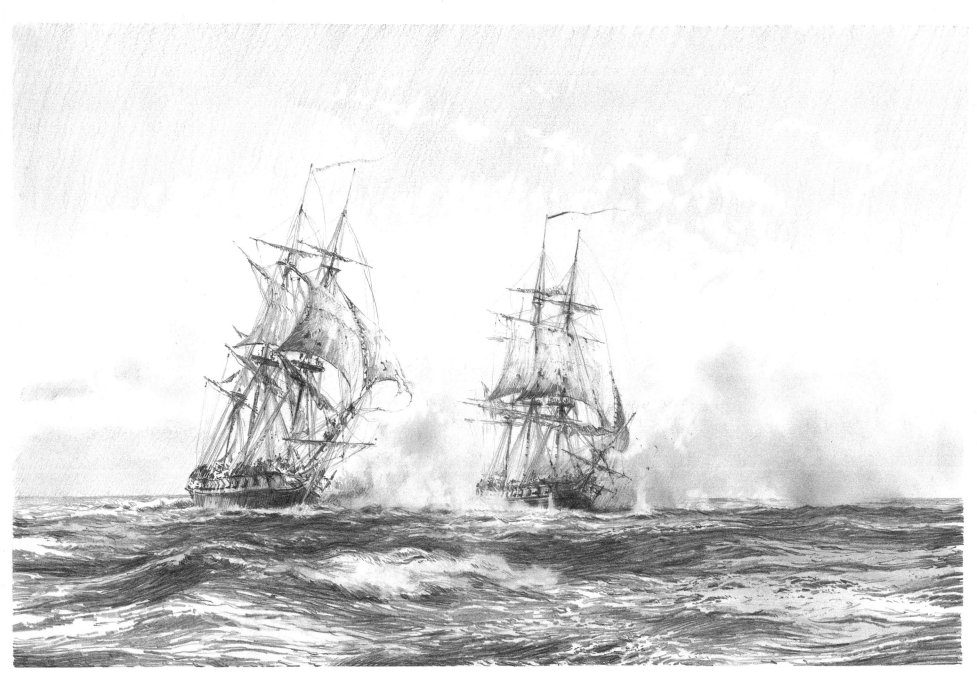

"Prepare to Board"

The Maritime Paintings of
Robert Taylor

FOREWORD BY

The Rt. Hon. Sir Edward Heath K.G., M.B.E., M.P.

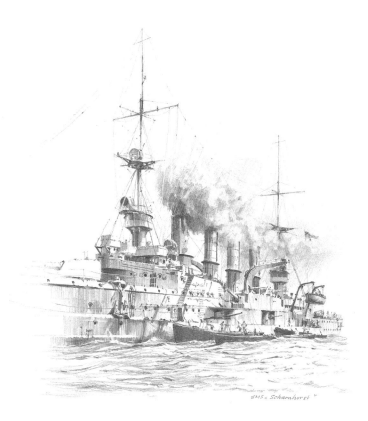

SMS "Scharnhorst"

David & Charles

A DAVID & CHARLES BOOK

First published in the UK in 1999
First paperback edition 2003

Distributed in North America
by F&W Publications, Inc.
4700 East Galbraith Road
Cincinnati, OH 45236
1-800-289-0963

A catalogue record for this book is available from the British Library.

ISBN 0 7153 1704 0 paperback

Printed in Singapore by C. S. Graphics Pte Ltd
for David & Charles
Brunel House Newton Abbot Devon

Visit our website at www.davidandcharles.co.uk

David & Charles books are available from all good bookshops;
alternatively you can contact our Orderline on (0)1626 334555 or
write to us at FREEPOST EX2110, David & Charles Direct, Newton
Abbot, TQ12 4ZZ (no stamp required UK mainland).

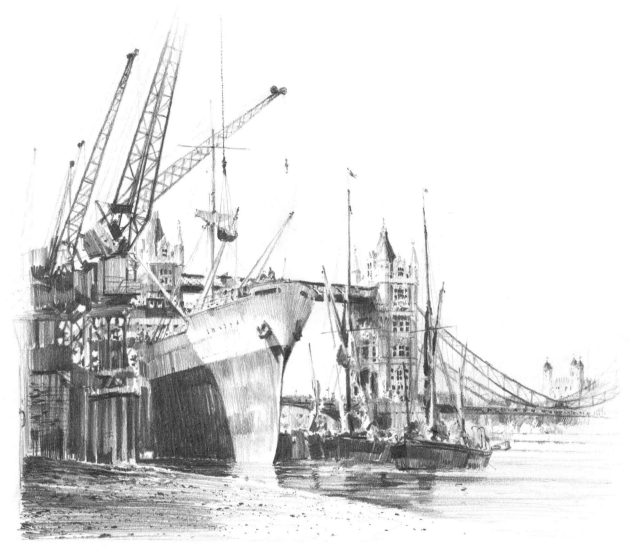

The South bank of the Thames at Bermondsey near the entrance to St. Saviour's Dock.

Contents

THE PAINTINGS
Introduced by the Artist

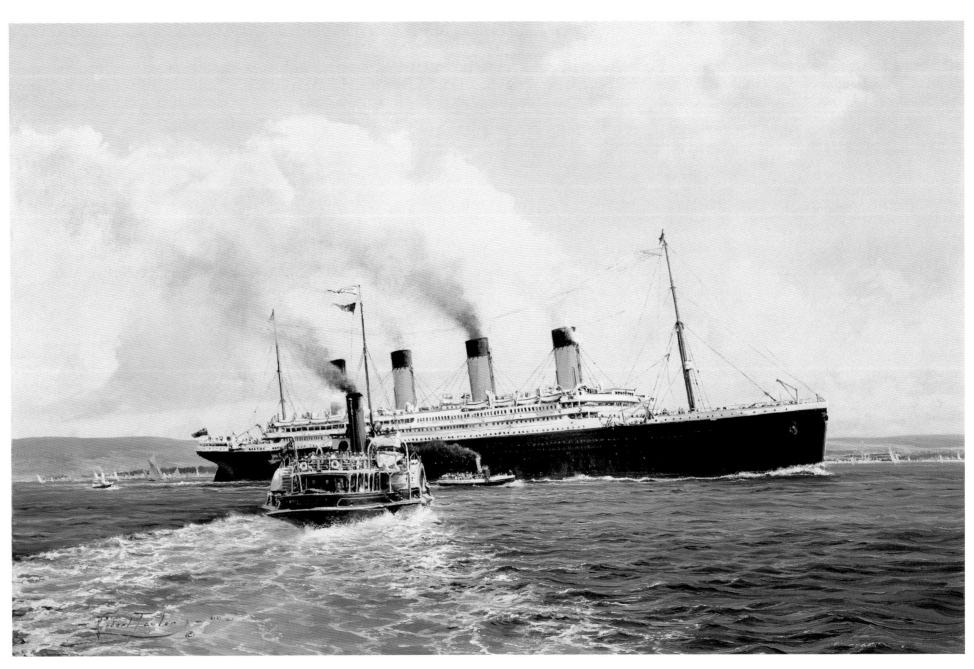

Maiden Departure – the SS Titanic steams down the Solent, 10 April 1912

Foreword

The paintings by Robert Taylor of two of my ocean racing boats, the first and the second *Morning Cloud*, are among the great joys of my life.

Painted some twenty years ago, they brilliantly recall for me that I won the Sydney to Hobart Race in 1969 in *Morning Cloud* I and captained the British Ocean Racing Team, which won the Admirals Cup against eighteen other international teams in 1971.

In these two paintings of mine, Robert Taylor has perfectly captured the many different aspects of ocean racing. There is first the accuracy with which he depicts the boat and its details, as well as the characteristics of the crew. There are the contrasting weather conditions in the two races in which the boats were fighting hard for success. Each painting is suffused with the spirit of competing against one's rivals, against time, against the weather and above all, against the sea. The pictures conjure up every aspect of ocean racing and bring back the liveliest recollections of victories; one at home and one overseas.

Those all over the world who are the proud possessors of Robert Taylor's three collections of aircraft activities, both in peace and war, will now have the opportunity of extending their enjoyment to ship and boats of almost every kind and of almost every age. Many give one a thrill whilst others fill lovely moments of calm reflection.

Perhaps one of Robert Taylor's outstanding characteristics is his use of colour in his works. Always smooth and effective, it brings out superbly the light and shade of our ships in whatever situation they find themselves. This is a glorious collection to be treasured for life. I greatly hope others will follow.

Edward Heath

The Rt. Hon. Sir Edward Heath K.G., M.B.E., M.P.

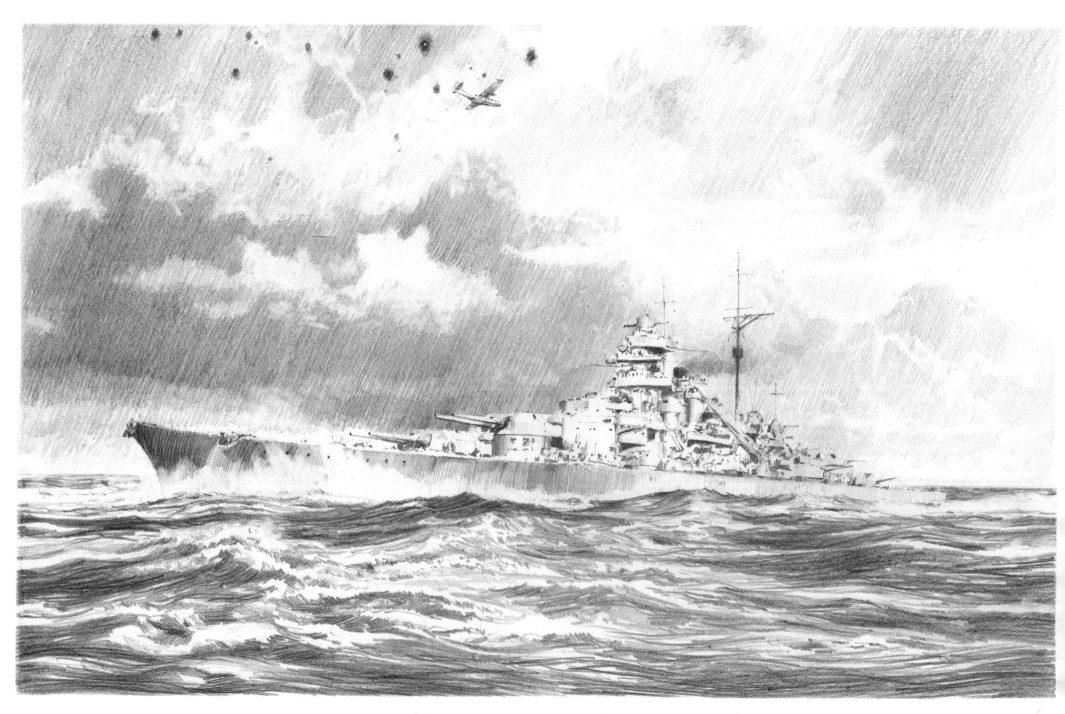

The German battleship Bismarck is spotted by a PBY Catalina of Coastal Command. This position was immediately flashed to Admiralty Intelligence, thus sealing her fate. — 1030 on the 26ᵗʰ May 1941.

Introduction

by

Patrick Barnard

I first met Robert Taylor almost a quarter of a century ago. At the time he was a talented and much sought-after picture restorer working for a respected art gallery in Bath, the west of England city where Robert has lived all his life. As he diligently laboured on the works of other artists he dreamed of one day becoming a professional artist himself. He knew he had it in him to succeed in the precarious world of painting; but he also had a wife, three children and a mortgage to consider.

When I got my first look at this young amateur artist's work, as a publisher of art I immediately recognised an unusual talent. I was sure that given the opportunity, the time to develop, and the will on his part, he would one day become more famous than many of the artists whose works he spent his days restoring. I was prepared to give him the chance to fulfil his dream if he was prepared to take the risk.

Robert had been employed in his job for fifteen years and, having all the usual financial commitments to think of, it was a momentous decision to have to take. What tipped the scales in the direction I knew Robert wanted to go was the loyal support of his wife Mary. She knew how badly Robert wanted to become a professional artist and was aware of his talent, so together they risked their future with a publisher they hardly knew!

With Robert's mind made up, I asked him a simple question: 'If you had to choose one subject to paint for the rest of your life, what would it be?' He didn't have to think for a moment; his answer was spontaneous. He replied, 'It would be ships and the sea,' and so that is where we started.

The intervening years have been an adventure, with many twists and turns, and a great deal of fun. From my point of view, much satisfaction has come from watching Robert mature and hone his skills to levels that today bring him respect, indeed adulation, from a huge audience scattered all around the world. As long as a decade ago, demand for his original paintings was such that he became backlogged by years; that situation has never changed. His limited editions continue in popularity, many appreciating to many times their original value.

Today he is as well known for his aviation paintings as for his marine subjects. That turn of events in the fascinating story of his career is interestingly covered by Robert himself in the pages that follow. I see a common thread however, that runs through all his paintings, whether they be aviation or maritime canvases: almost without exception his paintings portray his understanding of, and love for the elements. I would venture to say that no living artist paints the sea and the sky better, or with more feeling, and a hallmark of a Robert Taylor canvas is his panoramic treatment of sea and sky.

I have had the great good fortune to work alongside Robert throughout his professional career, to have watched this amiable character at close quarters on his inexorable rise to the top of his profession, and to be able to count him and his family among my friends. So to be asked to write these few words for the book that means so much to Robert is indeed a privilege.

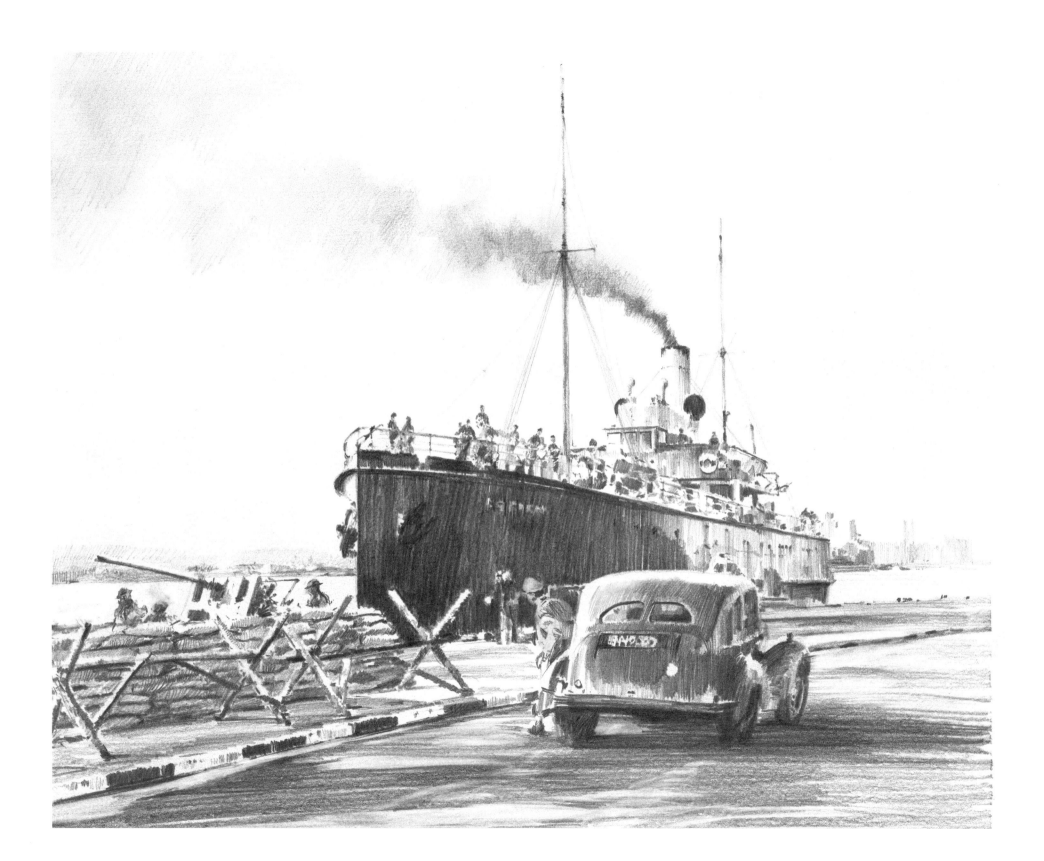

A Passage in Time

The schooner 'America' wintering in Venice

This is my fourth book but the first to be published featuring my maritime paintings – all three previous volumes have featured the aviation paintings which have occupied much of my time during the past two decades. When I started my professional career over twenty five years ago I was painting almost nothing but marine subjects; however, within a year of taking the plunge, a turn of events took my work away from the sea. There was nothing planned about the way it happened; it was a simple case of one thing leading to another, in much the same way that most events occur in life.

While I was a rookie professional artist back in the 1970s the British government had, in their infinite wisdom, elected to do away with aircraft carriers and handed all their Phantom and Buccaneer jets over to the RAF. They doubtless accepted them with great gusto. It was a momentous decision on the part of the government that puzzled many, was not welcomed by Her Majesty's Admirals, and thoroughly upset all the highly trained Navy pilots of the day.

My publisher felt that the demise of the era of great aircraft carriers (and with it naval aviation as we then knew it) was something that should be recorded in some way. I was asked to complete a painting of HMS *Ark Royal* – the third British aircraft carrier to be so named. The painting was reproduced as a print and, thanks to a double-page spread in the *Daily Express* showing the painting, my first military print became one of the biggest-selling prints in the UK

Photo: Robert Wizner

that year. Over 5,000 copies were sold within the first two days following the appearance of the feature. By the time the dust settled almost 30,000 prints had been bought.

11

The newspaper story led to a ten-minute television feature on the BBC's popular nation-wide programme Pebble Mill, during which I was invited to discuss a number of my marine paintings. This national television exposure led in turn to a string of new commissions. Among the requests for paintings came commissions from the Fleet Air Arm Museum. Being the aviation wing of the Royal Navy the requirement, though essentially of a maritime nature, quite naturally was for naval aircraft. Though I had always had an interest in aviation I had not painted aircraft seriously up to that point, but when

The old fish market at Looe

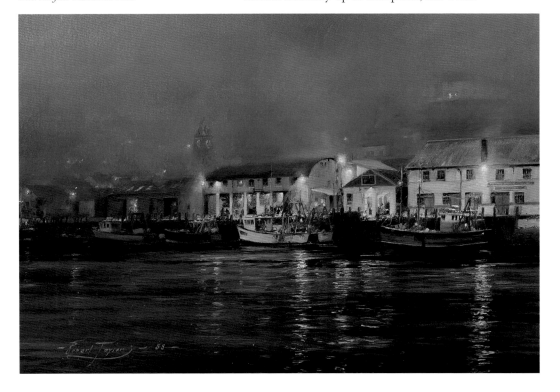

completing the first commission I found that I both enjoyed the subject and that it came fairly easily to me.

There were many similarities between this and painting ships and the sea, and perhaps because the sky plays such an important part in both marine and aviation art, the paintings worked pretty well. My first efforts were well received and soon led to further commissions covering a wider range of aviation subjects. Over the ensuing years the opportunities for me to paint marine subjects became fewer and fewer.

When, as a boy, I first became interested in art, it was marine paintings that fascinated me the most. There was something special and exciting about maritime art that I didn't see in other types of paintings. The deep impression the early marine painters made upon my youthful senses has throughout my life drawn me to the sea. For me there has always been a sense of romantic adventure about ships, particularly the old sailing craft. I marvelled at paintings of old pirate galleons, fighting ships of sail, the fast tea clippers, ocean traders, coastal sailing barges, classic pre-war steamers, even modern warships. As a youngster these maritime paintings conjured up in my mind epic travels of exciting adventurers and my imagination would allow me to sail with them to exotic distant places. Places that, even in my wildest dreams, I never expected to visit.

As I grew more and more interested in art and started my own first stumbling attempts with the brush, it was the great marine masters that I looked to for my

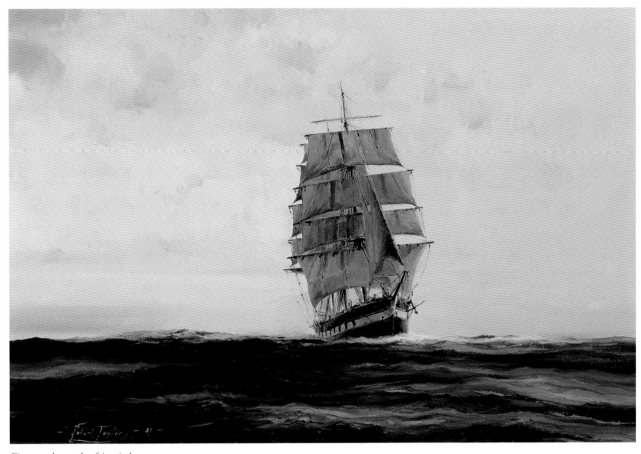

Fine weather and a fair wind

excitement for maritime art has never left me. I confess that I am never happier than when I am painting a ship heaving on a mountainous sea under a big, dramatic sky.

Throughout the past two decades while painting aviation art I have always managed to find time to paint marine pictures, and this book contains a selection of those paintings. One or two were painted early in my professional career and when I look at them today, happy as I am with what I achieved then, I can see how I would approach them differently today.

The weather, such a vital part of any marine painting, has always intrigued me. Forever changing its mood, it weaves a constantly changing pattern of colour, light and shadow which continually alters the way we see things. To the sailor, the weather is everything. It controls the wind and the waves, and hence the way his ship behaves. For those who make the sea their lives, the weather controls their destiny.

It was the fifteenth- and sixteenth-century Dutch maritime artists that first fired my imagination. To this day their superbly detailed and colourful paintings hold me spellbound. They have been such an influence on everything I have painted – marine and otherwise. I love the crisp, vivid colours with which they adorned their canvasses, and the way they portrayed so accurately the ships of their era in such a painterly fashion. Others who have influenced me are Brooking, van de Velde, Pocock, Luny, Chambers, and, most significantly, Montague Dawson. These artists dealt primarily with the sea, and less with the peripheral subjects, thus giving me so much pleasure and satisfaction in viewing their paintings. I am fortunate to have as a friend the great maritime painter John Stobart. John is a modern master whose magnificent compositions, painted with awe-inspiring technique, are an inspiration to a host of present-day artists – me included!

inspiration. I would hurry home from work in the evenings to sit up half the night doing my best to make copies of their masterpieces. Looking back, possibly I would have been better employed making simpler paintings, because all my early attempts were depressingly poor. But I persevered and slowly – incredibly slowly it seemed at the time – my efforts began to improve. I was, and still am, in total awe of the ability the Old Masters had to paint the sea and the sky.

For a long time it seemed an impossibility that I might emulate, even in the briefest way, the magnificence of their paintings, but gradually my understanding and appreciation of their techniques improved. I found I was able to translate some of what I had learned into my own paintings. Making copies of the marine Old Masters was a tremendously exciting period of my life, and that feeling of real

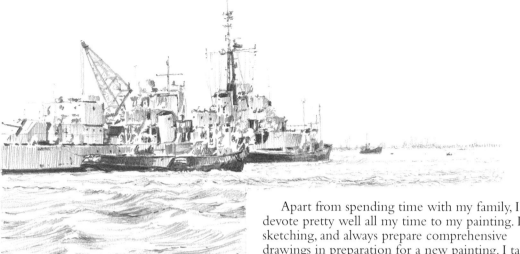

U.M.S Cavalier at Husbands boatyard Southampton

HMS Kelly – convoy escort

Apart from spending time with my family, I devote pretty well all my time to my painting. I enjoy sketching, and always prepare comprehensive drawings in preparation for a new painting. I take my sketchpad and a pencil wherever I go. My art has given me the opportunity to travel the world, something I dreamed about as a boy but never imagined would happen. Many people have helped me along the road and I have made countless friends, and when people tell me that my work gives them pleasure, I count my blessings: I am only doing what I always wanted to do!

In my notes accompanying the paintings in this book I have endeavoured to provide some insight into how I go about my work. I speak of some of the difficulties and frustrations encountered, discuss the importance I attach to research, and try to give some feel for the joy I experience when creating a painting. I hope these musings will make it all the more interesting as you, dear reader, turn the pages.

The preparation of this book has rekindled my desire to paint more marine subjects. Perhaps as the years roll by my art will come full circle, and I shall again return to the sea. Only time will tell.

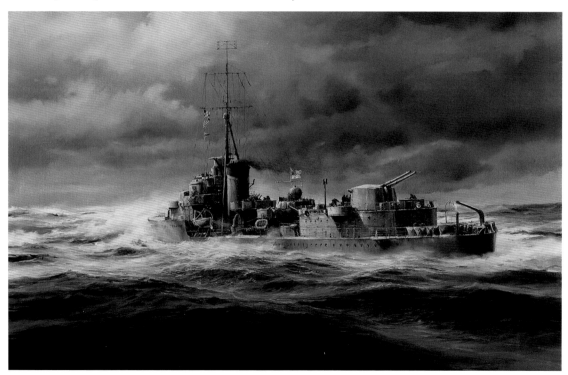

H.M.S HMS ROYAL berthed alongside the semaphore tower, Portsmouth.

THE PAINTINGS
INTRODUCED BY THE ARTIST

Battle of the Nile

When Rear Admiral Horatio Nelson destroyed Napoleon Bonaparte's French Fleet in Aboukir Bay on 1 August 1798, he secured for Britain a supremacy at sea that remained unchallenged for 150 years.

Reconstructing great sea battles from the early days of sail can be one of the great challenges for a marine artist. Ambitious as it may be, there has been no shortage of artists who, over the years, have been prepared to have a go at painting such scenes. As a youngster I was enthralled by dramatic canvasses depicting classic fighting ships of the line locked in combat, and even to this day the sight of a well painted sea battle continues to start my adrenalin flowing. I suppose it was always going to be just a matter of time before I took up the painting challenge myself.

The better known the battle the more documented it has usually become, and thus the more experts there are out there ready to examine the artist's effort, analysing and looking for inaccuracies in the interpretation. But herein lies the key to my attitude towards this kind of retrospective painting. Given the most accurate diagram of a sea battle as it is believed to have occurred, six artists painting retrospectively, all with the same information, will produce six entirely different interpretations. Each will create his or her own unique version of the event, using whatever licence is required to conjure up the image and atmosphere that the artist visualises in his or her own mind. This, for me, is what makes art so exciting.

When I painted my version of the *Battle of the Nile* I spent much time at the Maritime Museum at Greenwich researching the event, but when I had gathered as much information as I needed, I wanted to let my imagination go to work as I composed my particular version of Nelson's magnificent victory. As the painting was quite widely promoted as a print, I was half expecting to be admonished by some learned historian for some detail of inaccuracy, but fortunately I heard nothing!

By way of comparison, I have completed scores of paintings depicting scenes from World War II, most of which have been composed with the advantage of speaking with people who actually took part in the events portrayed. It has never ceased to amaze me how varied half a dozen different eye-witness accounts of the same event can be! I have often wondered how many differing versions of the event I would have got had I been able to talk to some of Nelson's sailors!

The painting shows the action in Aboukir Bay at about 1800 hours on 1 August 1798. To the left, the British ship *Goliath* engages the *Guerrier* while Nelson's flagship *Victory*, in the centre, fires a broadside into the French ship *Conquerant*. In the foreground French sailors, caught ashore by the British surprise attack, attempt to return to the *Apartiate*, itself shortly to become another victim of *Victory*.

Looking aft English ship of the line.

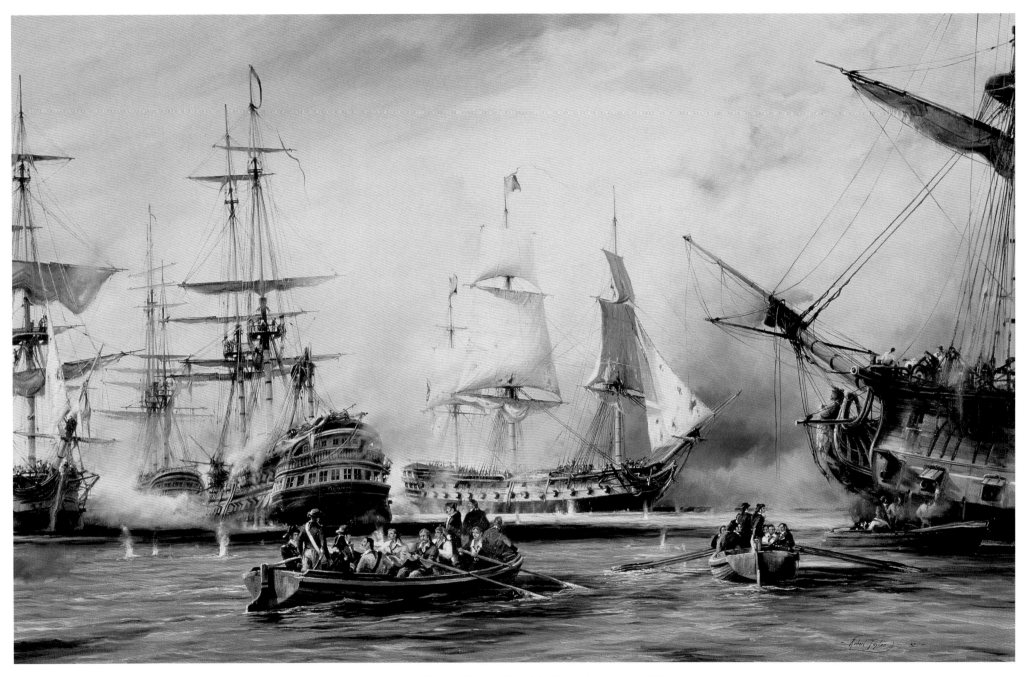

The Battle of the Nile – Aboukir Bay, 1 August 1798

In the collection of Mr and Mrs Robert James

Hornblower and the Atropos

What adventures lie ahead for Captain Horatio Hornblower as he takes command
of his new ship-of-war Atropos?

All paintings, whether depicting a specific event or pure figments of the imagination, are meant to be expressions from the artist's mind. Even when painting a well documented, even much photographed incident, the artist is expected to place his or her own interpretation on the event: it is this that gives a painting its individuality, indeed life.

Many paintings I have completed over the past twenty years have been recreations of actual events, and much of the information gathered for these paintings has come from personal accounts described to me by people who were actually present. While listening to these graphic accounts, pictures form in my mind in just the same way one visualises a scene described in a book. It is interesting to contemplate that no matter how detailed the author's description, everyone's visualisation will be slightly different.

I read all the *Hornblower* books as a boy. C.S. Forrester's vivid descriptions never failed to bring strong images into my mind, and reading *Hornblower and the Atropos* for the umpteenth time, I was again moved by the author's account of Hornblower's emotions as he approached his new ship for the first time. This painting is my vision of that poignant moment.

It is the winter of 1805. Across the water Bonaparte is losing the war against England. With her all-powerful Navy, England ruled the waves, her ships dominating all the great sea passages of the oceans. The *Atropos*, a 22-gun ship-of-war, is the newest addition to the all-conquering Navy, and seeing his recently launched command for the first time, Captain Hornblower is momentarily choked with excitement and emotion.

The painting shows Captain Hornblower, accompanied by his wife Maria, in the rowing boat as he approaches *Atropos*. Lying at anchor, her new paintwork and varnish gleaming in the crisp winter sun, she is a picture to behold. Around her there is busy Thames River traffic and the bustle of the early nineteenth-century port of Deptford.

18th Century fourth rate being careened on the Thames at low ebb.

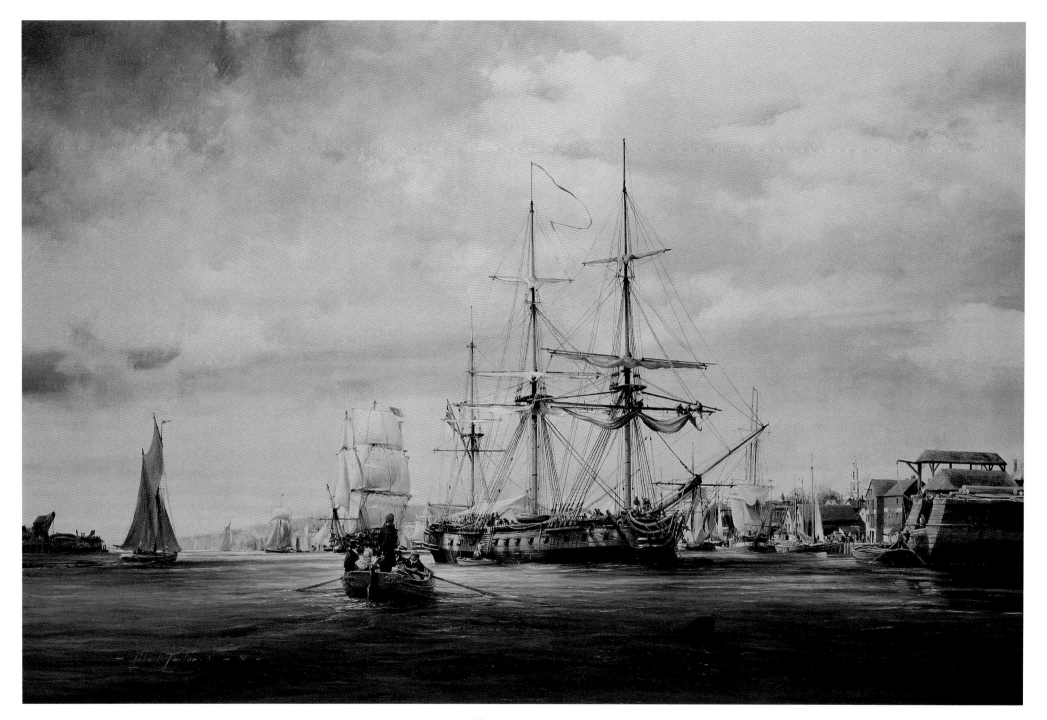

Hornblower and the Atropos

In the collection of Mr and Mrs Northeast

Battle of Trafalgar

When Admiral Horatio Nelson routed the French Fleet off Cape Trafalgar he won the single most decisive battle in naval history. Though not one English ship was lost, Britain's most famous naval figure died in the battle.

The most famous battle in naval history took place on 21 October 1805, when Admiral Nelson's British Fleet clashed with the Franco-Spanish force of thirty three fighting ships off Cape Trafalgar. The French and Spanish ships turned back towards Cadiz in a five-mile-long irregular line. Nelson, his ships in two divisions, each in a single column on a course at right angles to his adversary's, drove directly into the centre of the long Allied column, cutting it in two. In a five-hour battle eighteen Allied ships were taken; the remaining fled. Only eleven reached Cadiz. No English ships were lost, but Nelson was mortally wounded by a musket shot as his flagship *Victory* closed in furious combat with the French ship *Redoutable*.

The painting shows *Victory* breaking through the enemy line at 1300 hours. A broadside has crippled Admiral Villeneuve's French flagship *Bucentaure*, seen off her port side, while she fires a second broadside with her starboard cannons into the *Santisima Trinidad*. Just astern, the *Téméraire* manoeuvres to trap *Redoutable* between herself and *Victory*, and thus seal her fate. Admiral Nelson's victory thwarted Napoleon's plans to invade Britain, and gave the British Navy supremacy of the high seas that remained unchallenged for one hundred years.

Preparing for this painting I was able to spend many hours aboard *Victory*, Nelson's famous ship which is preserved intact at the Naval Museum at Portsmouth. While researching this painting, and that depicting the Battle of the Nile featured on page 17, I received much help and encouragement from the staff at the Naval Museum. I was rewarded by a comment from an official at the Maritime Museum at Greenwich: he kindly said that, in his opinion, my two paintings were the most realistic portrayals of these two historic battles that had been painted in recent times. I am sure others may have differing opinions, but his kind remarks were highly flattering and, more importantly for me at that stage of my career, tremendously encouraging.

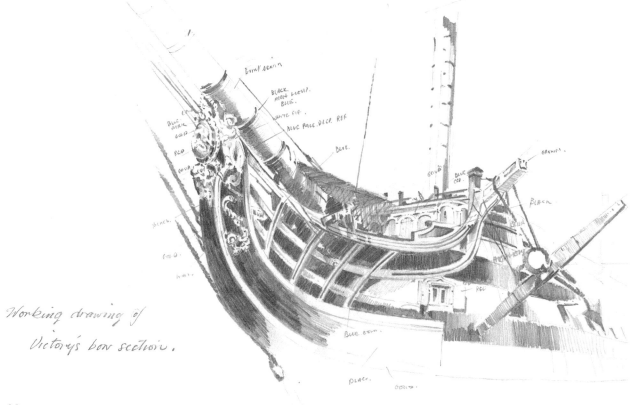

figure head 'Victory.

Portsmouth. 78.

Working drawing of Victory's bow section.

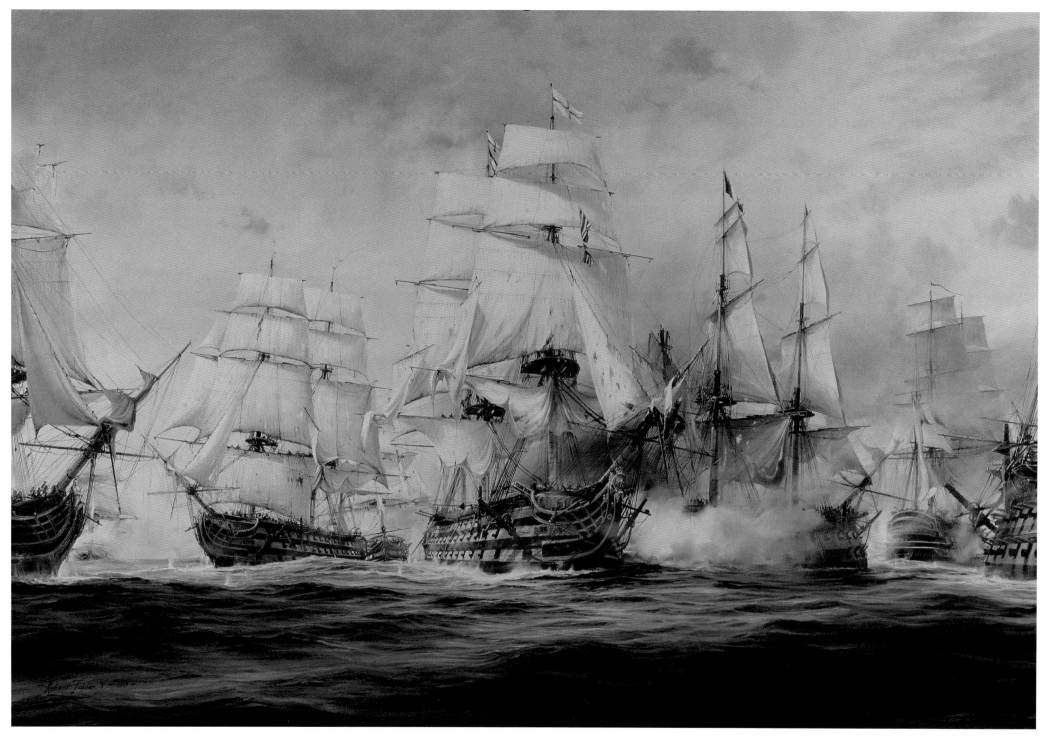

The Battle of Trafalgar – HMS Victory breaking through the enemy line – 21 October 1805

In the collection of Mr and Mrs Robert James

Hornblower and the Indefatigable

'Now the ships were broadside to broadside, running free before the wind at long cannon shot.'

The escapades of Horatio Hornblower, C.S. Forrester's dashing young eighteenth-century naval officer, always delighted me as a youngster. Re-reading his beautifully descriptive novels as I do from time to time, they never fail to rekindle my desire to paint sea actions from the past. Inspired by exciting accounts of seamanship and derring-do, I have made a number of drawings and paintings composed in my imagination from scenes so graphically described by this great author of the sea. *Hornblower and the Indefatigable* is the most recent.

It is the late eighteenth century; as the young midshipman Hornblower found himself assigned to the British Navy frigate *Indefatigable*, the mighty French and British fleets are locked in battle on the high seas. Early in his assignment aboard *Indefatigable*, under the charismatic captaincy of Captain Pellew, the young midshipman experienced the arduous task of blockading the ports off the west coast of France. Tossed around in continually stormy winter seas, the British frigate lay in wait ready to pounce on any French ship that ventured out of harbour.

Winter in the bay of Biscay brings incessant and violent weather: easterlies, their bitter chill freezing the ocean spray to the rigging, alternating with westerly gales hammering in from the Atlantic, bringing with them mountainous seas, driving the ships, hatches battened down and deck seams leaking, to seek the safety of a lee shore. After month on month of long nights, short days, constant soakings and cold discomfort, ships' crews were restless. Any diversion was welcome, especially the chance of taking a French prize.

On a cold day in January a break in the monotony came in the form of a 40-gun French frigate, attempting to run the blockade. Without ado, Captain Pellew gave the order to engage. *Indefatigable*, laid close to the wind and with yards groaning, gave chase, quickly narrowing the water between the two adversaries, bringing the enemy into range.

The French ship made a bold attempt to rake *Indefatigable* as now the ships were broadside to broadside, running free before the wind. With the ships parallel to each other the Frenchman fired a broadside in straggling fashion, *Indefatigable* lurching as, almost simultaneously, all her guns returned fire in unison.

My painting depicts the exchange of cannon fire between the two ships, *Indefatigable* on the left. Moments later, as the two hulls crashed alongside each other, the Frenchman was boarded and taken.

Eyes of the Fleet – a Royal Navy 36-gun frigate, circa 1790

Hornblower and the Indefatigable

Artist's collection

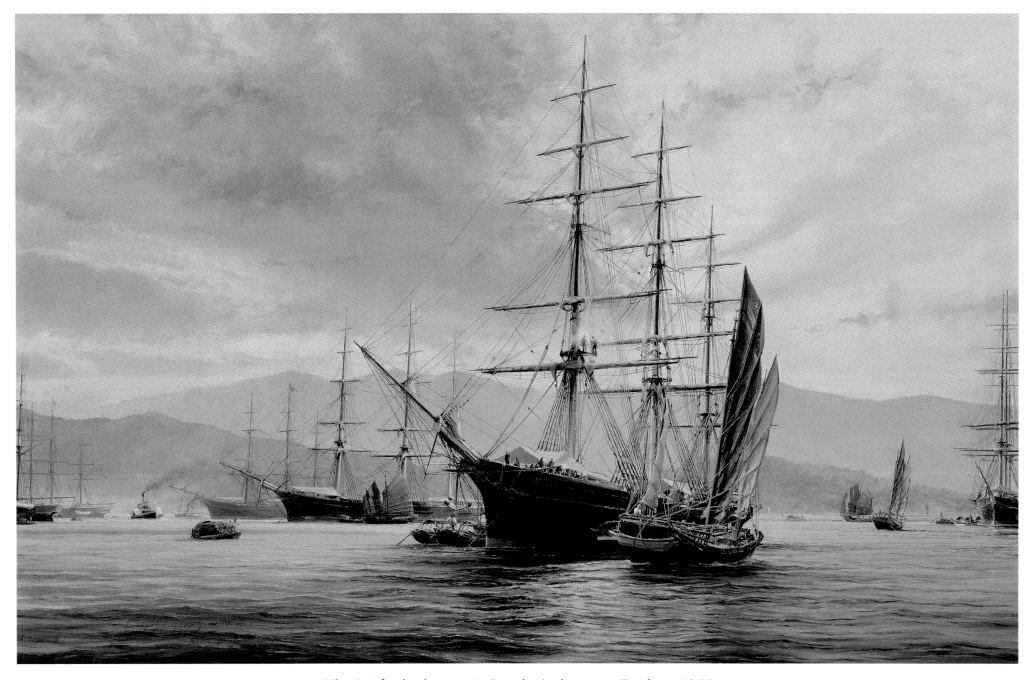

The Spitfire loading tea in Pagoda Anchorage at Foochow, 1857

In the collection of Mr Eugene Eisenberg

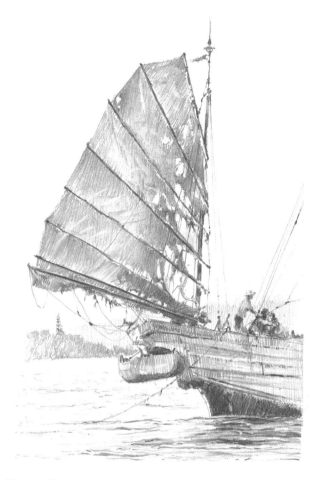

The China Tea Traders

When in 1832 Isaac McKina, a wealthy merchant from Baltimore, commissioned to be built a three-masted, square-rigged version of the rakish brigs and schooners of Chesapeake Bay, the first tea clipper was born.

Within a few years the New York shipbuilders were swamped with orders for fast new clippers capable of making the return voyage around Cape of Good Hope to China. Americans had become avid customers of Chinese tea, silks and other Eastern exotics, and there were fabulous profits to be made by the first laden China traders to reach New York.

When the American clipper *Oriental* brought a cargo of tea to London in 1850 she caused a sensation, and the race was on for British ship builders to produce fast vessels to challenge the existing American monopoly. The tea trade was flourishing; at its height the ports of New York and London, and in China, Canton and Foochow, were a constant hive of activity.

By 1860, Foochow had replaced Canton as China's major tea port. Situated on the Min River, reaching the anchorage was a navigational nightmare as the tall-masted ships wound their way twenty five

miles upstream, through towering canyons and tricky currents. But their reward was spectacular. Nestling among hills studded with temples, Pagoda Anchorage was a spectacular sight to behold. Sampans and junks loaded with tea chests brought their cargoes downstream from the plantations, some as far distant as a hundred miles upstream, to the waiting ships. Upon arrival armies of coolies transferred the chests aboard ready for their journey across the high seas.

My painting shows the *Spitfire* at Foochow in 1857. Surrounded by activity, tea and provisions are taken on board as a steam tug approaches, indicating she is almost ready to sail. Her journey to London will take 113 days.

Below are two smaller paintings I completed at around the same time as the one of the *Spitfire*. To the left, a junk glides downstream in the early morning mist, its deck laden with tea chests. The second painting shows another view of Pagoda Anchorage, with a clipper at anchor waiting to be loaded.

Morning Mist

Pagoda Anchorage

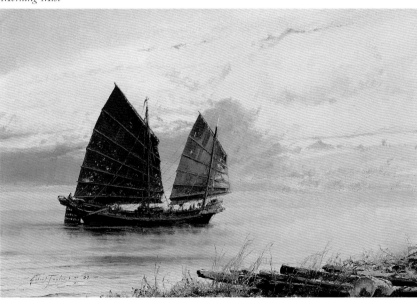

Clipper Flying Cloud

The glorious age of the clipper ships was short and sweet. During two short decades in the mid-nineteenth century the great trading routes on the oceans of the world became dominated by these fast, graceful and spectacular sailing ships.

Slim-hulled, with towering masts and great billowing sails, they were the greyhounds of the sea, and their record-breaking voyages made the news of the day, and made legends of their skippers. Never before had ships stirred the imagination of

The barque Mount Stewart bound for Australia, circa 1913

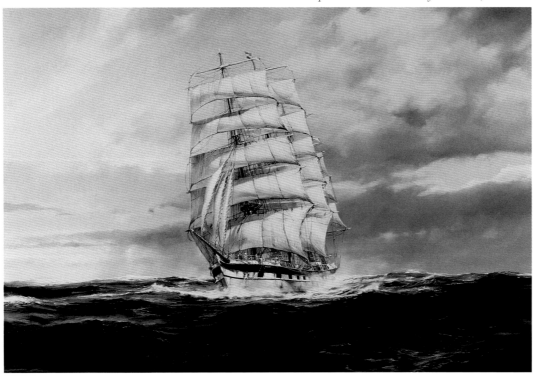

seafarers and public alike in the way these magnificent wooden ships did. Their long, sleek hulls, sharply pointed bows, raked masts, and massive spreads of canvas, drove them relentlessly through

windswept seas with breathtaking speed. During their brief time they represented the zenith of the age of sail and have fired the imagination of marine painters ever since.

Of the many sailing ships I have painted, this picture of the famous American clipper *Flying Cloud* remains one of my favourites. Its composition aimed to encompass all the atmosphere of a bustling oriental port, with people going about their daily routine – too busy even to notice the arrival of another clipper, as she slips majestically into the harbour.

The scene is set in May 1860. A good run has brought *Flying Cloud* from London to Hong Kong in ninety seven days. Her final destination will be Foochow, where she will load tea for the return voyage. The harbour is packed with activity and craft of every kind, and as the day draws to an end, across the water from Kowloon the large houses of the wealthy Hong Kong merchants are bathed in evening sunlight. This picture was a sheer joy to paint.

Flying Cloud was built in 1851 by the renowned American shipbuilder, Donald McKay, specifically for the California trade where passengers and crews made the perilous trip from the east coast ports around Cape Horn to San Francisco at the height of the Gold Rush. As the tea trade again flourished she became a visitor to China, and towards the end of her 23-year life she carried emigrants to Australia. *Flying Cloud* was a truly beautiful ship, and perhaps the greatest of all the clippers.

Mount Stewart, seen in the picture left, was built some forty years later. Commissioned solely for the Australian wool trade, she was a superb example of one of the last full-riggers. Built of steel, beautifully proportioned and perfectly sparred, she was admired by seafarers wherever she went. I painted this picture in 1979.

The American clipper Flying Cloud arrives at Hong Kong, May 1860

In the collection of Robert and Julia Sorenson

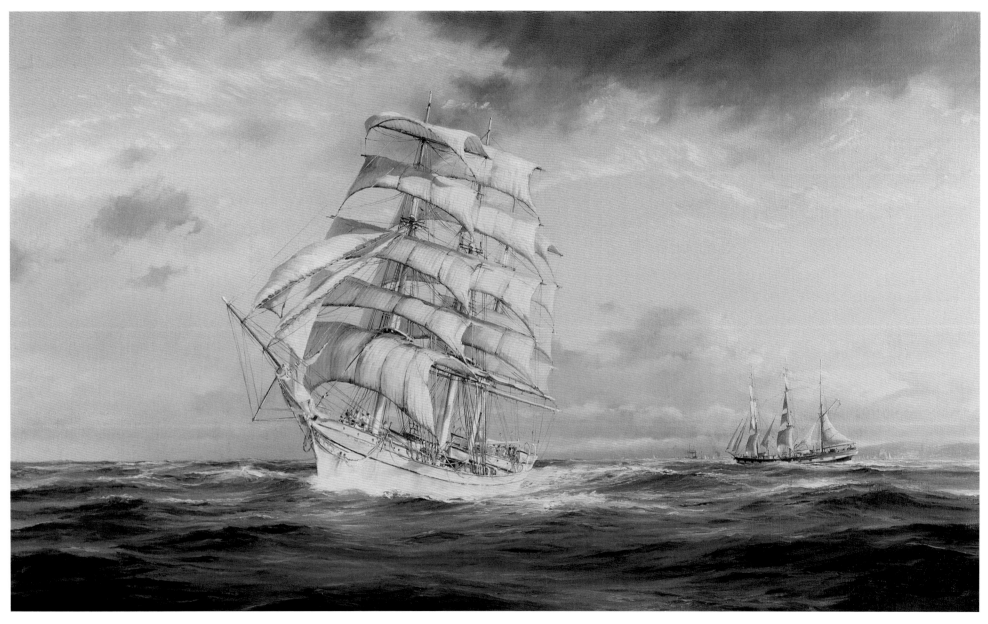

The passenger clipper Thomas Stephens sets sail from Glasgow, circa 1872

Private collection

The Passenger Clippers

As the new colonies of Australia and New Zealand beckoned hardy souls, offering them the hope of a better life, the shipping companies brought into service the first purpose-built ocean-crossing passenger ships – the passenger clippers.

During the second half of the nineteenth century there was much demand for passenger space from British emigrants intent on a new life in Australia and New Zealand. To accommodate the need, enterprising shipping companies started to build clippers for this express purpose, and the *Thomas Stephens,* shown here, was one of the finest examples of these ships.

Built in 1869, she had First-, Second- and Third-Class cabins, and even carried a surgeon for the long passage to the other side of the world. Until she was repainted in 1875 the *Thomas Stephens* was liveried in white, as distinct from the more usual black hulls favoured at the time.

After some twenty eight years under the British Flag, she was sold to Portugal where she ended her days as a sail training ship. Returning from a trip to America in 1916 she was reported missing. Her fate still remains a mystery.

Below is another famous passenger-carrying clipper, the *Waimate.* Owned by the New Zealand Shipping Company this handsome iron-clad clipper was the largest and fastest of the sailing ships built for the line. In twenty two years she completed no fewer than twenty two voyages to the Southern Hemisphere, each carrying an average of 350 emigrant passengers.

Although *Waimate* and others of her class provided the best of comforts available at the time, passengers often suffered severe discomforts from bad weather on their long voyage to southern seas. In 1899, now under Russian ownership and re-named *Valkyrian,* she set sail from Newcastle NSW for Iquique and was never heard of again.

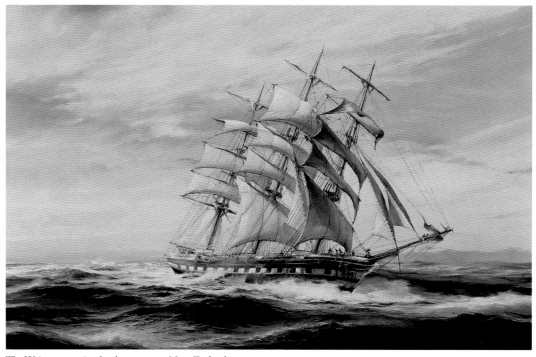

The Waimate running hard en route to New Zealand

Ocean Swell

Young apprentice sailmaker.

Between the beginning of 1877 and mid-1880 the famous Belfast shipyard Harland & Wolff launched some of the finest merchant sailing ships ever to be built in the British Isles. The last of these to be launched was British Merchant.

The passing of time does cruel things to man and machine. After a mere nineteen years successfully plying the high seas under the flag of the much respected British Shipowners Company, *British Merchant* was sold to a German company. In 1908 she caught fire while loading timber in Shilshole Bay, Seattle.

The fire was put out, but she never went under sail again. Bought by a local sea captain, she was converted into a towing barge. On 15 October 1909, loaded down with 3,000 tons of coal bound for Cordoba, she was inadvertently towed aground becoming a total loss. Thus ended the life of one of the finest sailing ships ever built. Here I have painted *British Merchant* in all her glory, ploughing confidently through a good swell during one of her many around-the-world voyages. That is how I thought she should be remembered!

Below are two paintings that include three of the best known British clippers. The picture on the left shows *Taeping* and *Thermopylae*, both having loaded tea at the Pagoda Anchorage, seen shortly after sailing from Shanghai. The race to off-load tea at London's top prices involved more than just the reputations of captains: large profits were at stake.

On the right the painting shows *Cutty Sark*, by far the most powerful of all the tea clippers, under full sail with a good sea running. This wonderful ship sailed the world's great trading routes under the Red Ensign between 1870 and 1895, when she was sold to a Portuguese company. Her career continued until 1922 when she was bought by a Captain Dowman and rigged as a sail training ship. She is now beautifully preserved in dry-dock on the Thames River at the Greenwich Maritime Museum, London. I have clambered all over this magnificent clipper many times.

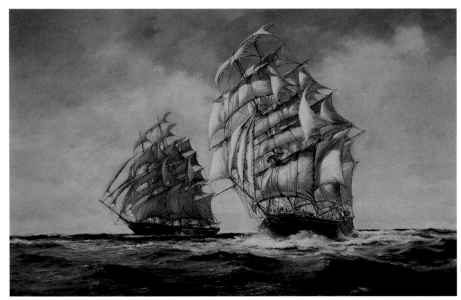

The Clippers Taeping and Thermopylae

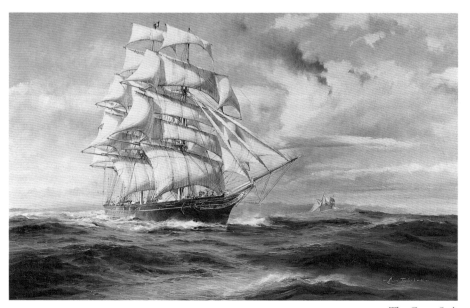

The Cutty Sark

30

Ocean Swell – the British Merchant in all her glory

In the collection of Mr and Mrs Tom Greenham

The Barque Glenogil
Off Liverpool Pierhead, 1900

'The sight of a tall ship as she slid gracefully into port after perhaps a hundred days at sea, having encountered all kinds of weather and hardship, was enough to stir the hardest of hearts.'

Commissioned paintings, which form the largest part of a professional artist's work, usually come with fairly specific briefs, clients to a large extent having some kind of vision as to what the finished work should look like. Sometimes the brief is so specific that it can override the creative juices, and I recall one commission I accepted many years ago – and a very prestigious one it was – where the venerable patron virtually wanted to compose the entire picture himself. I followed his wishes too closely and, though the client was happy enough, in my opinion the painting turned out to be a disaster. Since then I have learned to avoid taking any more than general direction from those commissioning my work.

From time to time commissions have come along where I have been given complete freedom to paint exactly what I wanted, and this painting, *The barque Glenogil off Liverpool pierhead, 1900,* fell into that category. In 1987 I received the commission from a major financial institution who asked me to paint three maritime scenes (the others appear on pages 35 and 37). The brief was simple: the client wanted the pictures to be centred around ocean-going sailing ships around the turn of the century, but apart from that stipulation, everything else about the paintings was left to me.

I decided that a harbour scene would provide plenty of interest and, being a busy trading port around the turn of the century, I decided to paint Liverpool. Situated on the Mersey River on the north-east coast of England, this old port was ideally situated for the Atlantic traders, and Liverpool became one of the important points of departure for emigrants heading for the New World.

I next needed to select a suitable ship that had traded out of Liverpool, and to find some dates which would give the painting authenticity. I had plenty of reference from the right period relating to the port, and while sifting through my maritime library, I established details of an arrival at Liverpool in 1900 made by the four-masted barque *Glenogil*.

Here I have depicted the *Glenogil* as she is towed upstream on the Mersey past Liverpool pierhead, where paddle steamers are embarking passengers for the river crossing. Across the water is Birkenhead. At this period in maritime history the great ports were a constant hive of activity during both the day and night, and I tried to inject a sense of this hustle and bustle into the painting.

Another four-masted barque, the German-owned *Peking,* is seen in the painting on this page.

The four-masted barque Peking

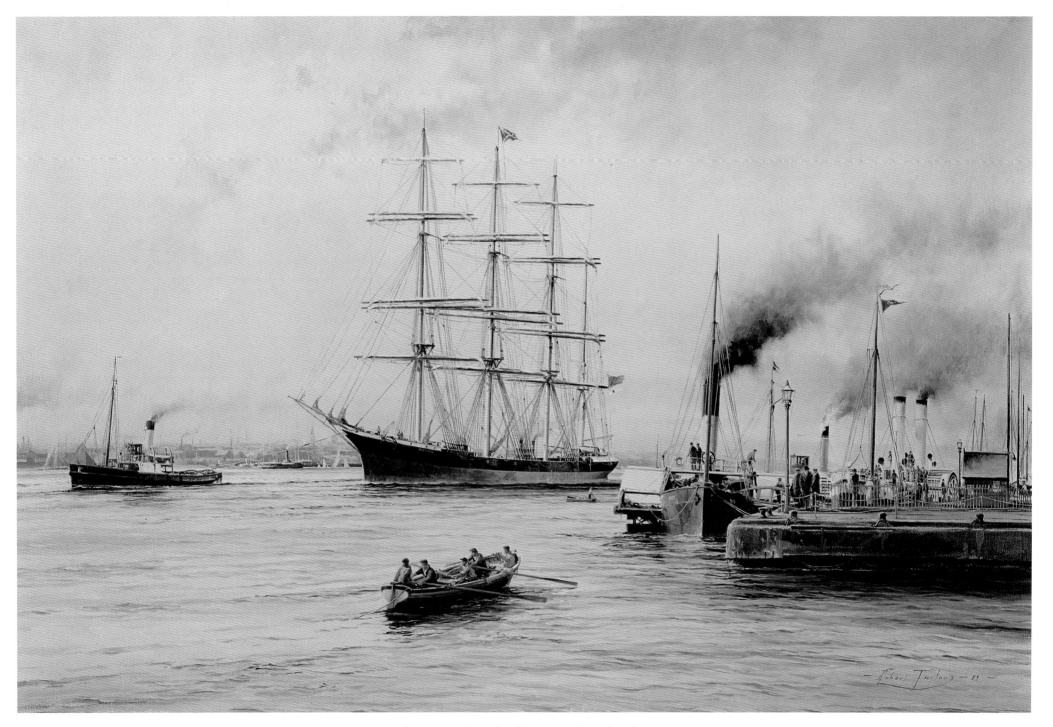

The barque Glenogil off Liverpool pierhead, 1900

In the collection of Allied Dunbar

33

The Loch Etive Outward Bound

Speaking of the Windjammer Loch Etive, *the great author Joseph Conrad, who served aboard as a Third Mate, said: 'She was built for hard driving, and unquestionably she got all the driving she could stand.'*

Barges at Maldon, Essex.

Evening Breeze

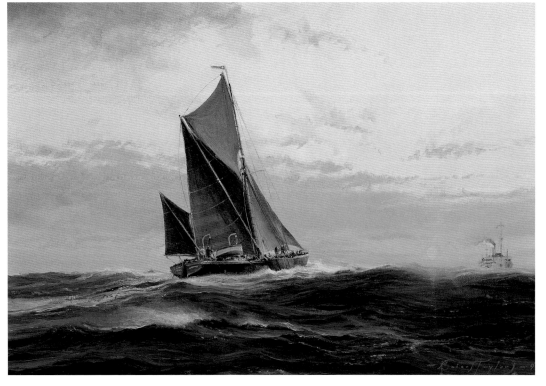

One of three commissions I received from a major financial institution, this painting features the *Loch Etive,* a well remembered iron-hulled clipper, the fifteenth vessel built for the famous Loch Line of Glasgow. Launched in November 1877, although built with good capacity primarily for the flourishing wool trade, *Loch Etive* was designed with speed in mind.

She started her maiden voyage from Glasgow on 9 January 1878 bound for Sydney, arriving after a fast passage of seventy six days. In the years that followed, under the forceful command of one Captain William Stuart, she successfully traded between Glasgow and other European ports, carrying wool, wheat, and jute from Australia and the Far East.

Captain Stuart, who skippered *Loch Etive* from the day she was launched, was a hard-driving captain with a nose for where the most profitable cargo was to be loaded, and was highly respected for his ability to make profits for his owners. He spurned offers to command big new steamships, remaining faithful to sail to the end. In 1894 he made his last voyage when, at the age of sixty three, he died aboard. The master mariner was buried at sea taking with him the proud record of never having lost a man overboard during forty three years as a ship's master! *Loch Etive,* and the highly respected Captain Stuart, were immortalised by the great author Joseph Conrad, who served aboard under Stuart as a Third Mate.

The painting shows *Loch Etive* in the Firth of Clyde departing Glasgow for Sydney, Australia on 15 October 1892. She will take on wool at Melbourne and return to unload her cargo on the Thames some six and a half months later. Also seen in the painting is another clipper under sail, and looking across the Firth towards Glasgow the waters are busy with coastal craft.

The painting on this page shows a Thames sailing barge negotiating a heavy swell in the Channel, *circa* 1920. These barges traded all around the English coast carrying cargoes between the ports of Britain and France, Holland and Scandinavia. A few well preserved examples survive today – the prized possessions of a few lucky owners!

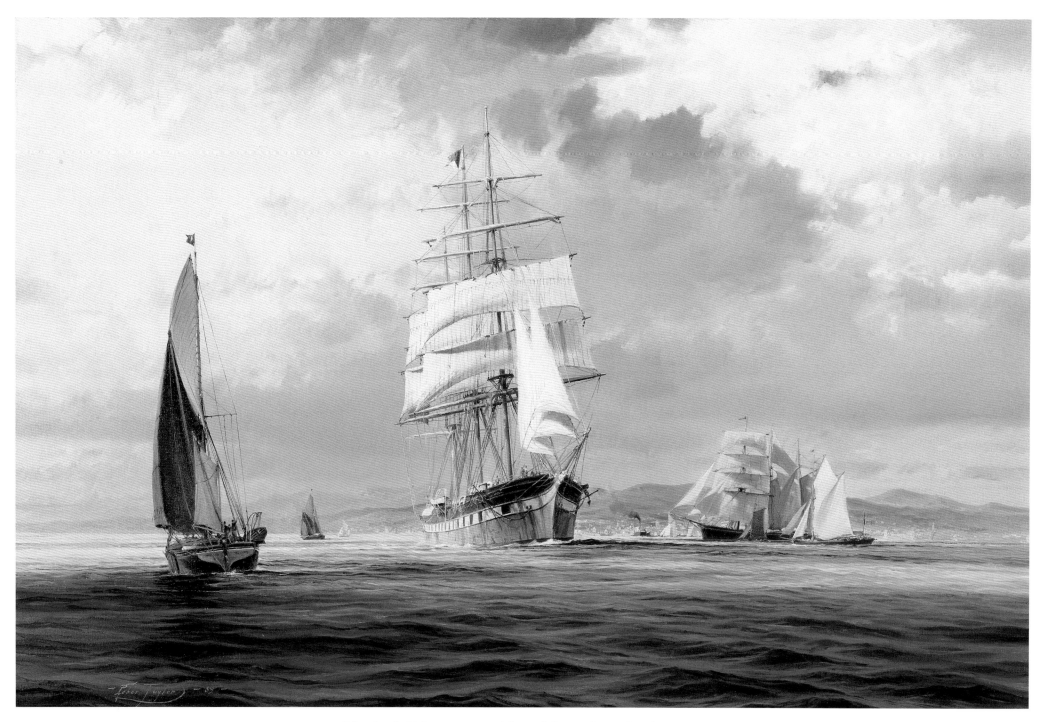

The Loch Etive – outward bound for Sydney, October 1892

In the collection of Allied Dunbar

Evening Arrival
– The Falls of Halladale

The great sailing ships were built for speed and their fearless captains drove them with every inch of sail, as hard as their straining masts could take. Capable of making 400 miles in a day, they were the culmination of the age of sail.

Built in 1886, *Falls of Halladale* was a magnificent four-masted barque belonging to the Falls Line of Glasgow. Built with a sail plan that was easily handled by a small crew she, and her sister ships of the Falls Line, had all the latest design features. Her snug rig allowed her to press on in heavy weather as long as her gear would stand, minimising sail handling and the dangers that this brought to the crew. Over 250 feet in length, these iron and steel vessels regularly took water across their decks, even in ordinary conditions, but the innovative fore and aft lifting bridges vastly reduced the danger of men being swept overboard.

The scene I have portrayed shows *Falls of Halladale* putting into Liverpool in 1903 – her subsequent voyage to San Francisco shortly afterwards nearly brought about her end. In attempting to sail around Cape Horn she met such ferocious weather that she blew out nineteen sails, sprang numerous leaks forcing most hands to the pumps, and had her fore and aft bridges smashed. Captain Johnson's decision to turn about and take the long around-world route past Cape of Good Hope instead brought about a mutiny. When she finally arrived in San Francisco 238 days out of Liverpool, with the ringleader secured in irons, she was a sorry sight.

Falls of Halladale is seen in the painting arriving in the port of Liverpool in the summer of 1903. The image below is a detail from a small oil sketch showing a German three-masted barque from the same period.

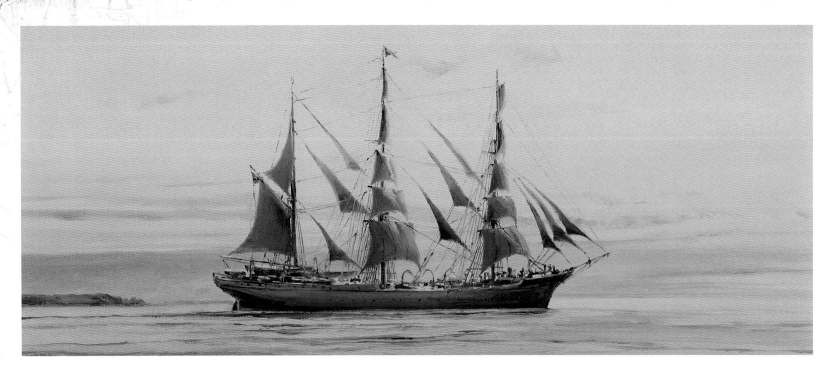

Shimmering Seas

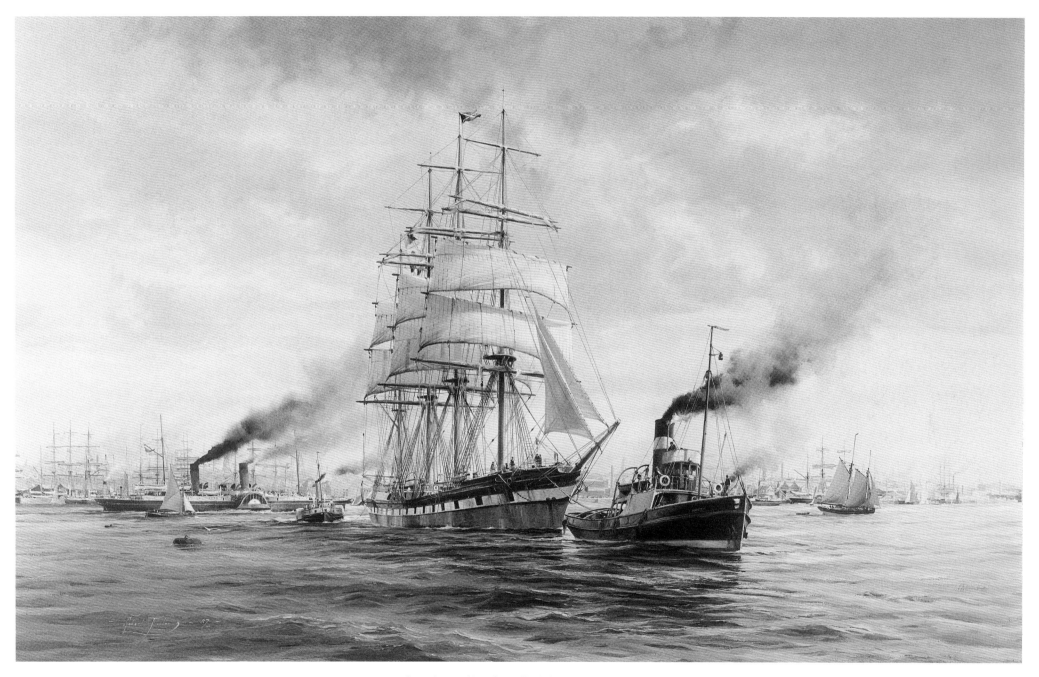

Evening Arrival – the Falls of Halladale arriving at Liverpool, 1903

In the collection of Allied Dunbar

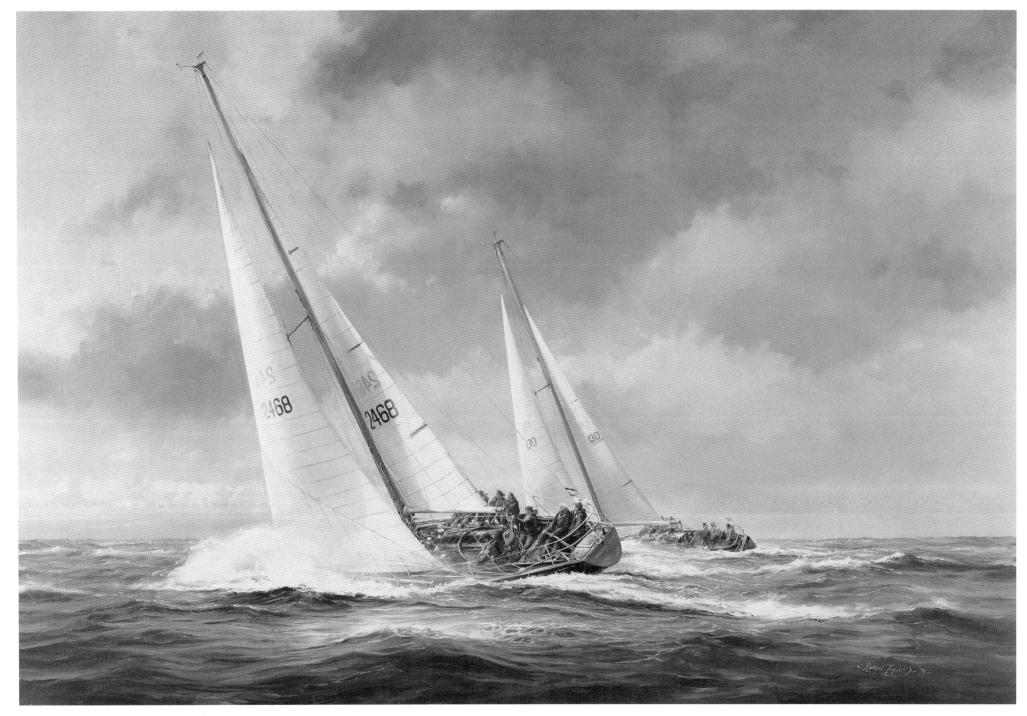

The Fastnet Race, 1971 – Morning Cloud racing with the Prospect of Whitby

In the collection of the Rt. Hon. Sir Edward Heath K.G., M.B.E., M.P.

Ocean Racers

Ocean racing is the ultimate form of competition between sailing boats. Since the first contest between America and Great Britain for the Americas Cup in 1851, wealthy sportsmen have spent fortunes in the quest for glory, and today interest in these magnificent racing yachts has never been more widespread.

With the advent of television we are today treated to close-quarters viewing as skilled crews manoeuvre and jostle for position, straining to get every ounce of performance from their highly tuned craft. Such scenes provide wonderful inspiration for an artist.

In the 1970s one of the best known British ocean sailors was Prime Minister Edward Heath, now Sir Edward Heath, and at the time his *Morning Cloud* racing yachts were some of the best known craft afloat. I was commissioned to paint his second *Morning Cloud* competing with her British Team companion *Prospect of Whitby* during the Fastnet Race of 1971, the most gruelling event within the prestigious Admiral's Cup.

To win the Fastnet – described as one of the most demanding races in the sailing calendar – is the aim of all ocean racers, and in 1971 victory went to *Prospect of Whitby* who, along with *Morning Cloud*, went on to win the coveted Admiral's Cup. This painting shows the two British yachts in close combat off the south-west coast of Cornwall, with Edward Heath at the helm of *Morning Cloud*.

Below is a study of his first *Morning Cloud*, during the 25th Sydney-to-Hobart race in 1969. When I showed the painting to Edward Heath, after studying it for what seemed like an eternity he said 'Robert, I need more suntan and a haircut, otherwise the painting is excellent.' He was a stickler for accuracy and detail, so I altered him accordingly. You don't argue with the Prime Minister!

Also below is another ocean-racing commission painted at around the same time. This depicts a scene from the 1983 Americas Cup and shows *Australia II* edging out a slight lead over *Victory 83*. The Australian challenger went on to lift the Cup, ending one hundred and thirty-two years of dominance by America.

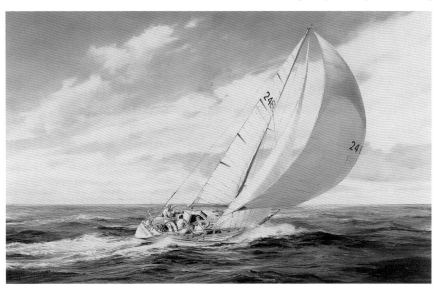

Running down to Hobart, 1969 – Morning Cloud

Americas Cup – Australia II racing Victory 83

The East Asiatic Squadron

The formidable German squadron, under the command of Vice Admiral Maximilian Graf von Spee, took part in the first major sea battle of World War I.

At the outbreak of World War I, Germany's East Asiatic squadron, consisting of two large armoured cruisers and three light cruisers under the command of Vice Admiral Graf Spee, travelled from their base at Tsingtao in northern China, across the western Pacific to the coast of Chile. On 1 November they were intercepted off the Chilean port of Coronel by a British squadron where, enjoying a large advantage in firepower, the encounter ended with a resounding victory for Admiral Graf Spee.

The Admiralty reacted swiftly, despatching a powerful naval force to the south Atlantic to confront the German squadron, and on 8 December battle commenced some 120 miles south west of the Falkland Islands. Outnumbered, outgunned and outpaced by the British force, the Battle of the Falklands was over by nightfall. Von Spee and the entire crew of his flagship *Scharnhorst* perished, and with *Liepzig*, *Nurnberg* and *Gneisenau* also sunk, the East Asiatic Squadron was routed. Only *Dresden* escaped, and when she was scuttled in Chilean waters four months later, the East Asiatic Squadron ceased to exist.

My painting shows ships of the squadron at anchor in a Pacific island bay prior to the outbreak of hostilities in 1914. The ships are, left to right, the light cruisers *Nurnberg* and *Dresden*, cruiser *Gneisenau*, and von Spee's flagship *Scharnhorst*.

SMS "Scharnhorst"

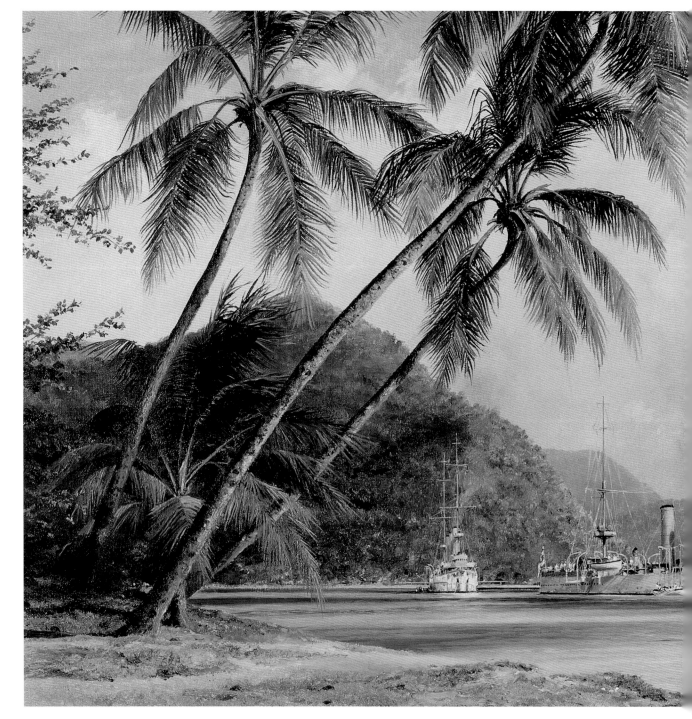

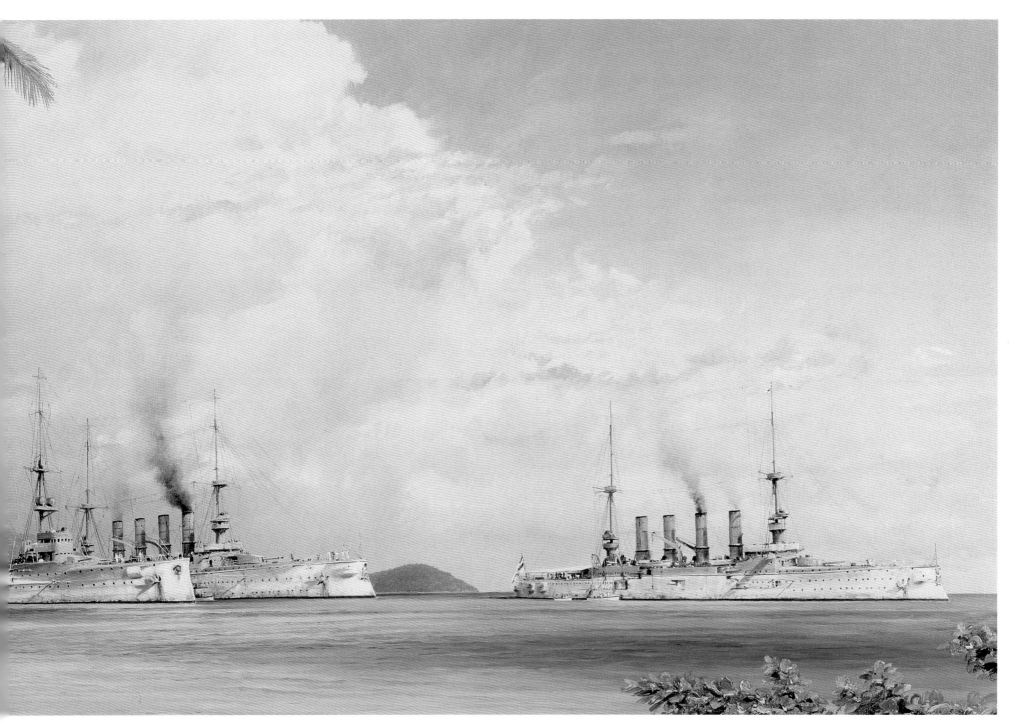

The German Navy's East Asiatic Squadron at anchor in the Pacific, 1914

In the collection of Mr Edgar Leicher

Wings of the Fleet

Big, ungainly, slow and vulnerable, aircraft carriers came to play a vital role in the Atlantic and Mediterranean during World War II, and were pivotal in the war in the Pacific.

"Full ahead both, hard a'port"

Aircraft carriers are perhaps the least graceful of all naval vessels, however surely the most functional. As such, these leviathans of the sea present an interesting challenge for the artist, and I relish painting them.

The earliest versions were no more than slabs of decking plonked on top of a sliced-off ship's hull, but when the first purpose-built carriers appeared they quickly developed a fundamental shape which, with the exception of the angled deck, has changed little over the intervening half-century.

With the advent of carriers, and the wide assortment of aircraft that flew from their decks, the nature of war at sea took on a completely new

complexion. Today these huge flat-topped vessels have displaced the sleek-hulled battleship to become the flagships of the great sea powers.

I have been fascinated with naval aviation since childhood, and it was through painting commissions for the Fleet Air Arm that I became so involved in painting aircraft. One of my early paintings of carriers was that of HMS *Glorious,* depicted here in the main plate.

Built before the war, *Glorious* became one of the early casualties. On 8 June 1940, after recovering RAF Gladiators and Hurricanes from Bardufoss following the German invasion of Norway, she was intercepted west of Narvik by *Scharnhorst* and *Gneisenau.* The German vessels opened accurate fire from a range of fourteen miles. With her decks crowded with aircraft she was unable to fly off her Swordfish to retaliate, and with shells landing on her decks, she caught fire, rolled over and sank.

The painting shows *Glorious,* her flight deck stacked with Swordfish aircraft, steaming towards Norway. In the foreground is a V&W class escort destroyer. My painting on the left shows HMS *Ark Royal* launching Swordfish in a force 9 gale late in the day of 26 May 1941. The aircrafts' successful and courageous torpedo attack sealed the fate of the mighty battleship *Bismarck.* There is more on this epic saga in the next chapter.

Completed in 1937, *Ark Royal* was the Royal Navy's most modern aircraft carrier at the outbreak of war. She served with distinction in the Atlantic and Mediterranean, her luck running out on 13 November 1941 when she was torpedoed by the German submarine U-18 some fifty miles off Gibraltar. Hit in the starboard side, her pumps couldn't keep pace with the flooding, and though she struggled to make port, *Ark Royal* sank the following day. The painting, which belongs to the Fleet Air Arm Museum, aims to give some idea of the hazardous conditions under which aircraft were courageously launched from carriers during war, when the need was there.

Launch against the Bismarck

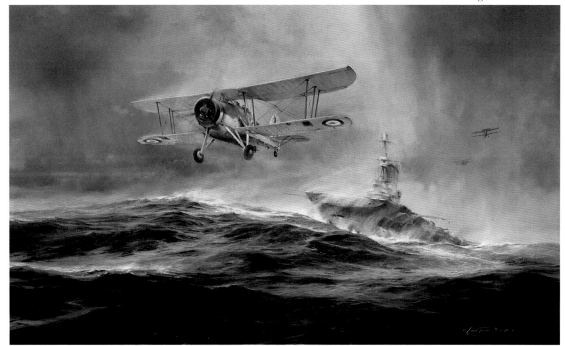

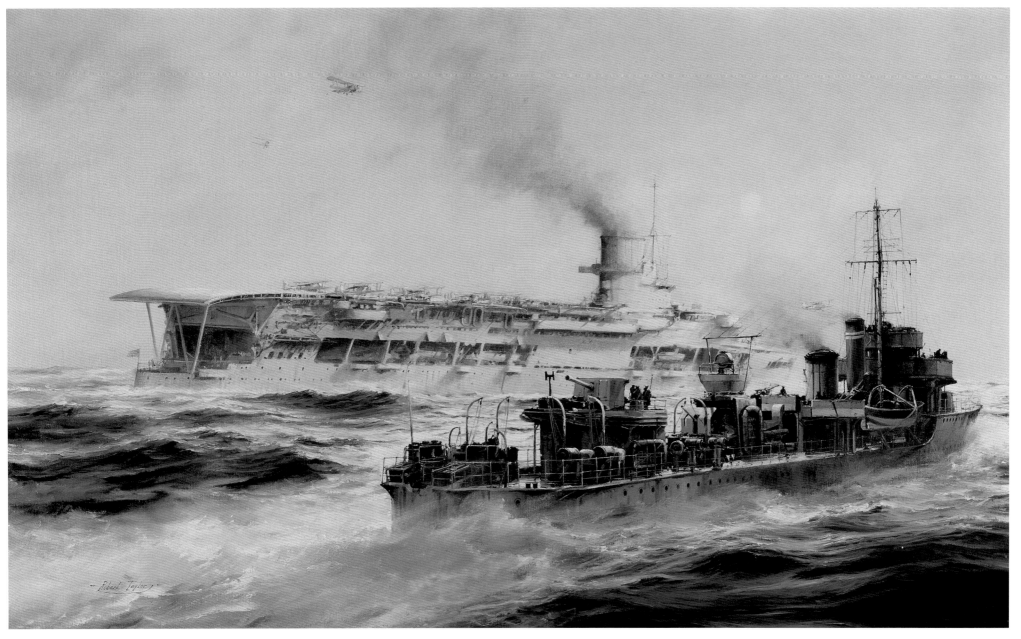

HMS Glorious, June 1940

Private collection

Battleship Bismarck

When the British battleships Hood *and* Prince of Wales *intercepted the German capital ships* Bismarck *and* Prinz Eugen *in the Denmark Strait in May 1941, there followed one of the most dramatic of all naval encounters.*

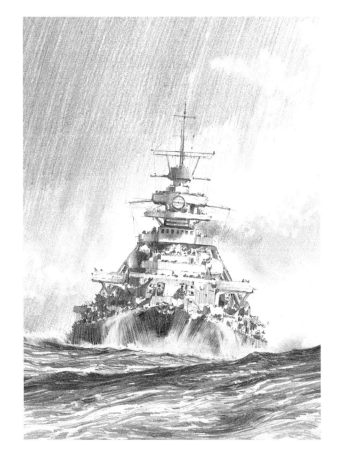

Within minutes of the first shots being fired, the *Bismarck*'s fourth salvo pierced *Hood*'s deck, detonating her two forward magazines. In one mighty eruption the *Hood,* pride of the Royal Navy, broke in two, and within seconds she was gone. Of the ship's company of 1,400 officers and sailors, only three survived. Outraged at the loss Churchill signalled just three words: 'Sink the *Bismarck!*' Thus began one of the epic sea chases of naval history.

Damaged by shells from the *Prince of Wales*'s fourteen-inch guns and losing fuel oil, Admiral Lutjens broke off the engagement and steamed towards the safety of the port of Brest. Evading the British warships for thirty two hours, *Bismarck* was eventually spotted by an RAF Catalina, which immediately reported her exact position. This is the moment I chose to capture in my painting.

Too far out in the Atlantic to expect any help from the Luftwaffe, Admiral Lutjens knew it would only be a matter of time, and when an attack by *Ark Royal*'s Swordfish torpedo bombers jammed her rudder, the *Bismarck*'s fate was sealed. Unable to manoeuvre and trailing oil, all she could do was wait while the British Home Fleet closed in for the inevitable final encounter.

Overwhelmed by British guns and torpedoes, *Bismarck*'s crew fought a gallant last battle, but the odds against her were too great. Watching *Bismarck*'s final moments Admiral Tovey said: 'She put up a noble fight against impossible odds, worthy of the old days of the Imperial German Navy.'

The painting below left shows *Bismarck* firing the fatal salvo at *Hood,* smoke from which can just be seen on the horizon. The *Prinz Eugen* is also in the picture. The painting at bottom right shows the last moments of the *Hood.*

I had the good fortune to meet Lieutenant Ted Briggs, one of *Hood*'s only three survivors, and to listen to his first-hand account of events. It was these conversations that gave me the title to the painting.

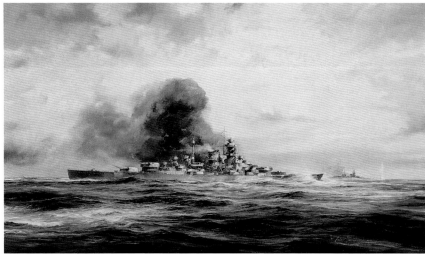

Salvo against the Hood

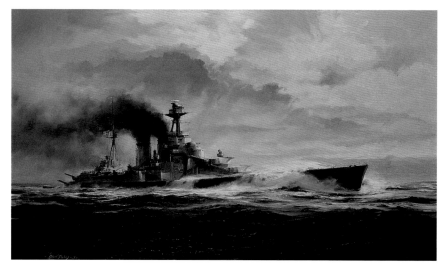

Last moments of the Hood

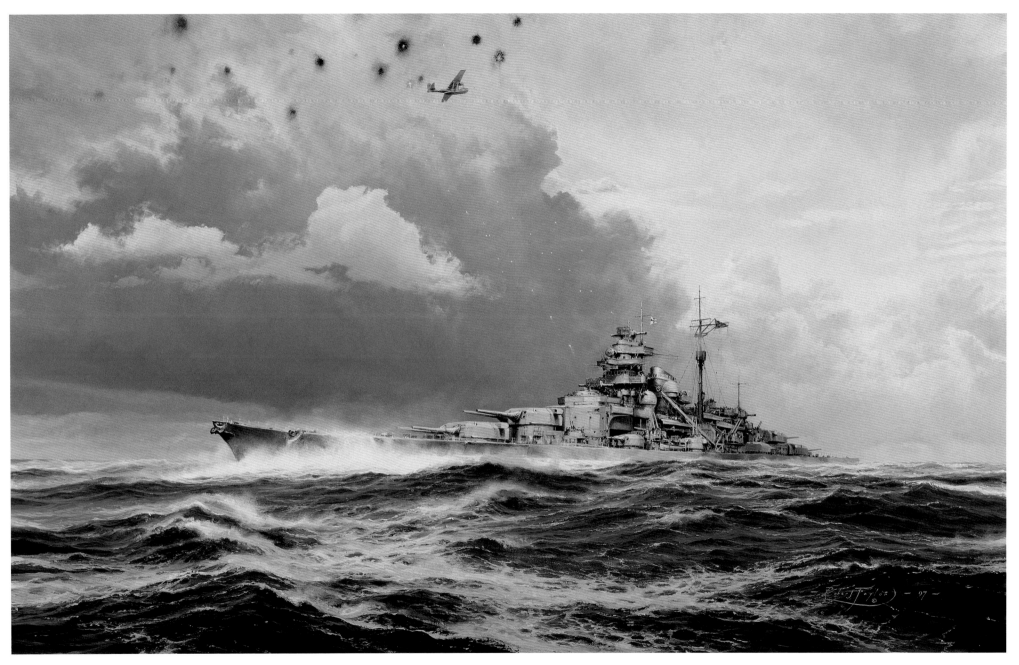

Sighting the Bismarck – the Beginning of the End, North Atlantic 1030 hours, 26 May 1941

In the collection of Mr Edgar Leicher

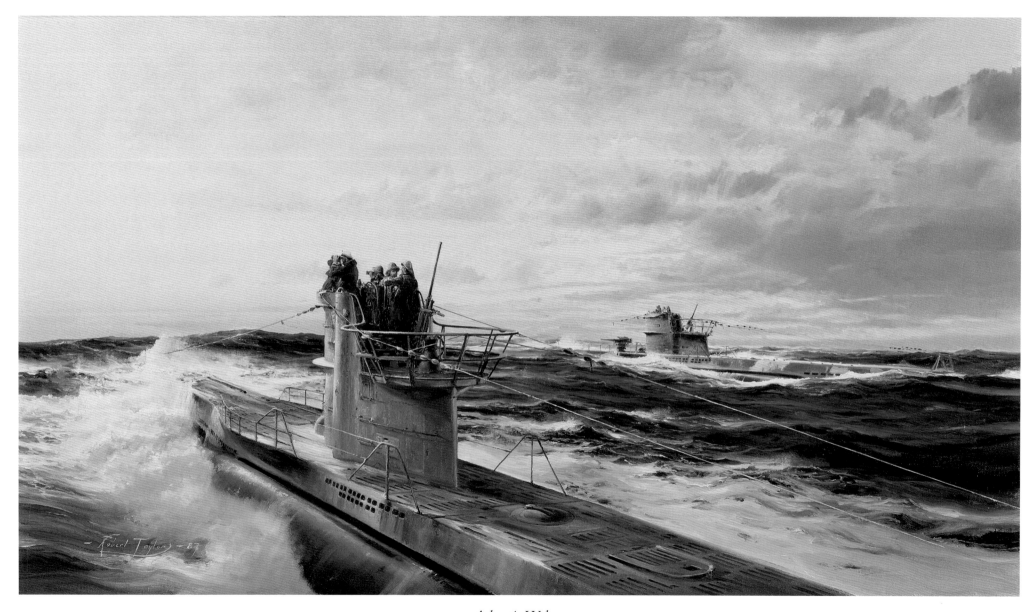

Atlantic Wolves

In the collection of Mr Rene Vos

The Undersea War

Lone warriors, greyhounds of the sea, German U-boats were the ever-present scourge of the merchant shipping lanes, the secret menace that haunted all Allied surface vessels.

'HMS Shappoi' returns from a successful operational sortie in Norwegian waters against German shipping 19 April 40.

W inston Churchill claimed '...the only thing that really frightened me during the war was the U-boat peril.' He was of course referring to the awesome statistics – over 2,770 merchant ships were sunk by U-boats in World War II – but, in my view, all submarines have a perilous aura about them that is difficult to define.

Quite unlike any other kind of maritime vessel, these coffin-shaped craft are designed for the sole purpose of hunting their prey by stealth, prowling unseen beneath the waves. They are the hunter-killers of naval warfare, and with their shark-like, somewhat eerie shape, they seem to have danger written all over

them. Yet in a curious way, like the shark, there is a certain fascination about the submarine.

Some years ago I met the well known commander of U–333, Peter Cremer, one of just three senior U-boat commanders to survive the war. Over 500 U-boat captains were lost, so he was either very lucky or very good; I suspect both. The extraordinary thing was that his grandmother was the daughter of a British Naval Officer. Peter commented that had he been born into the previous generation, he probably would have fought on the other side. He also said he had needed to keep his British ancestry very quiet at the time he joined the German Navy!

Atlantic Wolves is the painting that brought about my meeting with Peter Cremer in 1987. At that time he was the General Manager for Sperry Electronic Systems in Germany. A few years earlier he had published an account of his experiences as a U-boat captain in a book entitled U–333, and I drew much inspiration from the meeting and his graphic descriptions inside the pages of his book.

The painting shows U–333 in the mid-Atlantic making a rendezvous with another German U-boat. This was a particularly dangerous time for a submarine, and the crews were always especially vigilant while on the surface. I carefully included a group of men in both conning towers busy scanning the horizons for the first signs of trouble. In U–333 Peter Cremer is seen staring intently through his binoculars, and to increase the tension I added a small puff of smoke coming from just over the horizon.

The painting on this page was a private commission and finds HMS *Sceptre* moored in Scapa Flow. Built in 1943, she was an 'S' Class design. These submarines served in an offensive role in all three main theatres of the war – Home Waters, the Mediterranean, and the Far East. Amazingly, a complement of forty four souls were crammed into these small vessels.

HMS Sceptre prepares to depart Firth of Forth

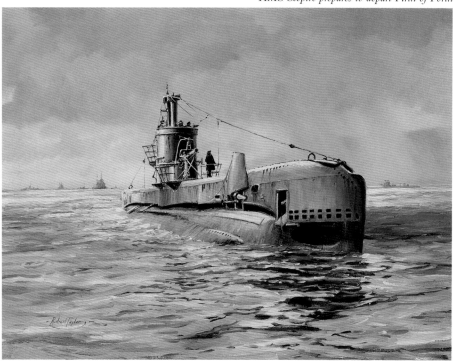

The Battle of the Atlantic

The bridge of an Atlantic convoy escort

Had Britain been unable to win the Battle of the Atlantic, the island nation's defeat in World War II would have been inevitable. To keep the vital shipping lanes open, every available ocean-going ship was thrown into the front line — even trawlers!

The value of cargoes, so perilously carried across the Atlantic between 1939 and 1943, far exceeded all the treasures plundered by the merchant ships of old. Without the continuous supply of fuel, munitions, raw materials and food, the nation's ability to defend itself would have quickly evaporated. Churchill knew this; he said '...Dominating all our power to carry on the war, or even keep ourselves alive, lay our mastery of the ocean routes and the free approach and entry to our ports...'

With German U-boats lying in wait both in the Atlantic and in the shipping lanes converging on Britain, the heavily laden merchantmen were under constant threat. Many were old and slow, and with each convoy's speed dictated by the slowest-moving vessel, naval escorts were usually hard-pressed to keep the ships together — and therefore vital for protection.

I have always loved the shapes of the pre-war ocean-going trawlers, with their purposeful bows, wooden bridge structures and towering funnels which were usually belching forth clouds of black smoke. They seem such unlikely ships to go to war, but nevertheless proved themselves an integral part of the nation's survival.

Many, such as His Majesty's Trawler *Sapphire* featured in this painting, had been taken over by the Admiralty and fitted with asdics and depth-charges. Initially given the task of patrolling the approaches to the ports, many were pressed into convoy protection duties owing to the desperate shortage of escorts. Their slow speed and small depth-charge carrying capacity limited their success against the U-boats, but they provided an invaluable service standing by crippled merchantmen and rescuing survivors from sunken ships, leaving their better-equipped partners to hunt down the enemy.

Sapphire is seen here in a heavy swell in company with a County Class cruiser, her depth-charge rails visible over the stern. The painting on this page shows the destroyer HMS *Kelly* on escort duties in the western approaches in 1940. After completing my painting of *Kelly*, a certain Admiral phoned to say I had failed to show the shelters above the torpedo tubes located amidships and fitted at the time of my picture, and could I please add them. I didn't like to tell him prints had already been made from the painting, and it was too late! Some months later he phoned again, most apologetically, to say he had been wrong, the shelters had been added later, and suggested that in the interests of accuracy I should now remove them. All's well that ends well!

HMS Kelly in the Western Approaches, 1940

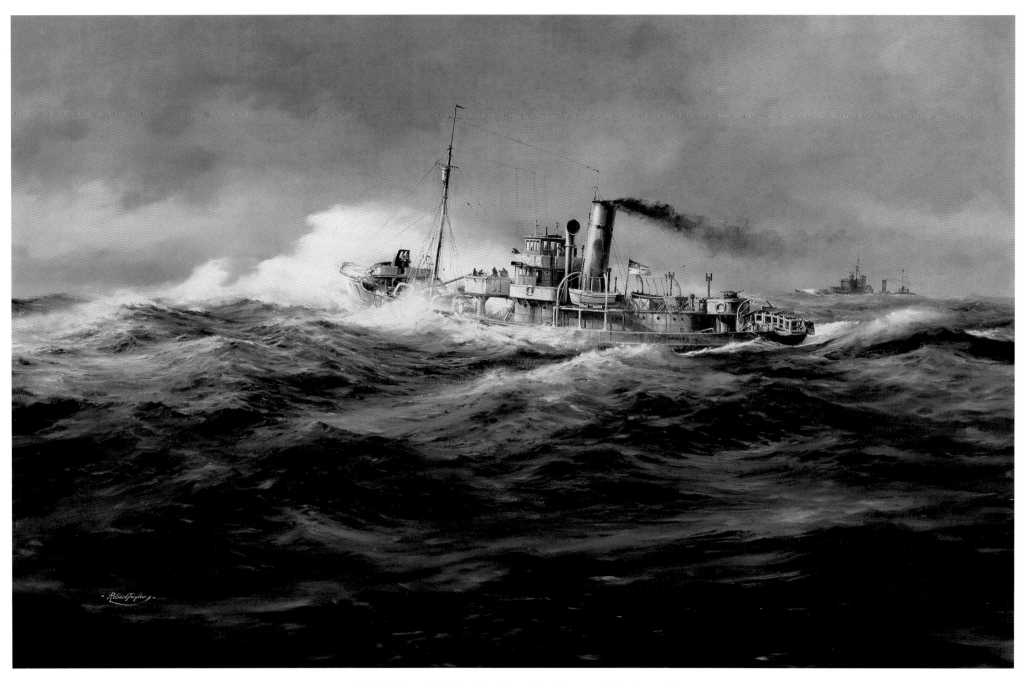

HMT Sapphire battles through a heavy Atlantic swell

Private collection

Last of the Destroyers

'Atlantic convoy seen over the destroyers
Port depth charge thrower.'

'As a wartime captain of a destroyer, and in command of the 5th Destroyer Flotilla, I have taken a keen personal interest in the preservation of HMS Cavalier – the last survivor of the classic destroyers. Robert Taylor's picture of HMS Cavalier is magnificent. He has captured perfectly the colours of the Arctic waters. His picture of my old command, HMS Kelly, is also superb.'

Mountbatten of Burma

In 1978 I was commissioned to paint two pictures of World War II destroyers as part of an ambitious project to preserve the only surviving example of the classic British destroyers. HMS *Cavalier*, following decommission, was lying at Husbands boatyard in Southampton Water, her fate in the hands of a small band of dedicated people striving to keep her alive. Among those was no lesser figure than Lord Louis Mountbatten – arguably the most famous of all destroyer men.

My publishers, the Military Gallery, had put forward a project involving limited edition prints from the two paintings, and had persuaded Lord Mountbatten to sign the prints also, on the basis that his signature would help raise vital funds. Happily it all came to pass, and a considerable sum was handed over to the Trust which helped save her, and she survives today as a museum ship.

HMS *Cavalier*, seen in the painting below, joined the Home Fleet in 1944, and won Battle Honours on the infamous Arctic convoys in 1945. I spent some time aboard her making sketches, but in 1978 she was equipped vastly differently from her old wartime configuration, so much delving into her past was necessary before a painting could be begun.

The second painting in the pair (page 51) shows HMS *Kelly*, with Mountbatten in command, steaming out of Grand Harbour, Malta, in 1941. Known throughout the Royal Navy for her endless succession of daring exploits, and the courageous leadership of her skipper, legend had it that dockyard workers believed the war must be over if *Kelly* ever spent a night in port!

Her end came on 23 May 1941 during the Battle of Crete. Attacked by waves of Stuka dive-bombers, she was hit while turning at full speed. She capsized and sank with the loss of 130 men.

Following announcement of the prints made from these two paintings, and the publicity given to the HMS *Cavalier* project in the national press, I was invited to appear on BBC National Television. After the programme was over I was told, to my complete amazement, that the studio had never before received so many calls enquiring for more information while the show was on air. So much happened to me following that ten-minute TV appearance, my life was never the same again.

HMS Cavalier on Arctic convoy duty, February 1945

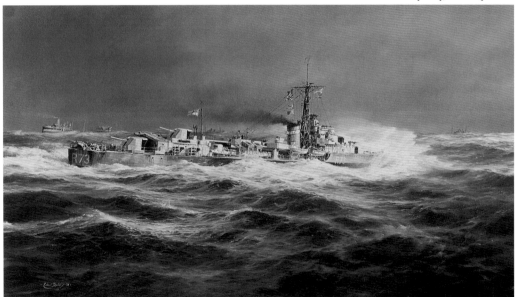

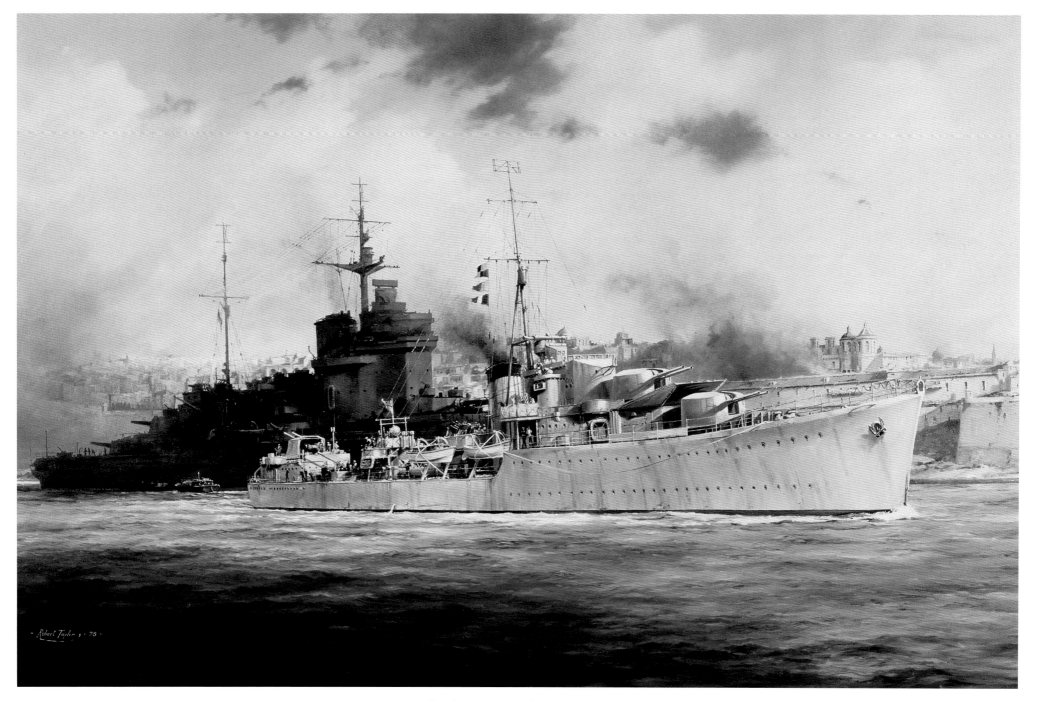

HMS Kelly departs Grand Harbour, spring 1941

In the collection of The Imperial War Museum, London

The Battle for Malta

Isolated in the eastern Mediterranean, the tiny island of Malta was strategically vital to the Allied Campaign in North Africa. Knowing this, the Axis powers endeavoured to cut off all supplies and bomb the island into submission. Her only lifeline was the sea.

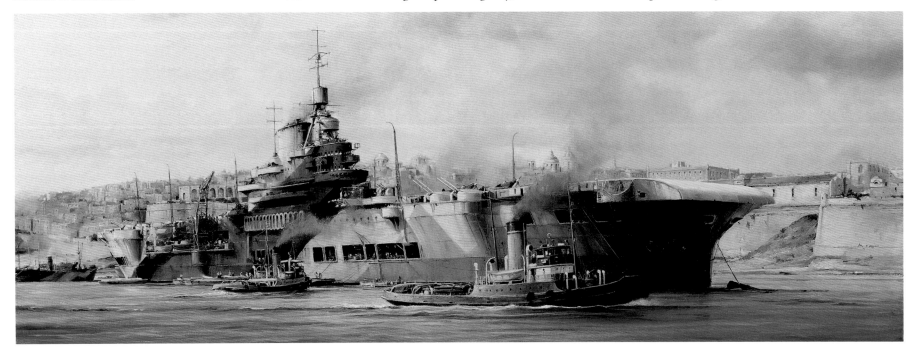

The carrier Victorious off Lascaris Battery Malta 42.

Illustrious in Grand Harbour

By August 1942, after two years of continuous aerial attack, the dockyards and airfields on the island of Malta had been blitzed out of operation, allowing Rommel's supply ships to cross to North Africa almost unopposed. Getting convoys past Gibraltar and right across the Mediterranean without heavy loss was an impossibility.

With the island's population near starvation, a last-ditch effort was made to reach it with a convoy that was code-named 'Operation Pedestal'. Of the fourteen merchantmen that set out, only five got through to Malta. One was the Texaco tanker *Ohio*. Carrying vital fuel, without power, she was towed into Grand Harbour on 15 August, barely afloat.

My painting shows the *Ohio* on the previous evening, still sixty miles out from Malta. HMS *Bramham* is lashed alongside providing way, and HMS *Penn,* nearest, and HMS *Ledbury* are providing protection and assistance, while RAF Spitfires beat off the last desperate attempt by enemy aircraft.

Researching the painting, Canadian Spitfire pilot Rod Smith, who had shot down an Italian bomber during the action, helped greatly with my understanding of the episode. He later wrote complimenting me on my work, as did Admiral of the Fleet Lord Lewin who had been on one of the destroyers: 'I signed 950 prints from your *Ohio* painting and I enjoyed looking at every one of them.'

The picture below is a detail from a painting showing HMS *Illustrious* in Grand Harbour, Malta, in 1941. *Illustrious* had played a major role in the Battle of Taranto when, on 11/12 November 1940, her naval pilots, flying Swordfish biplanes, sank one Italian battleship and damaged two more.

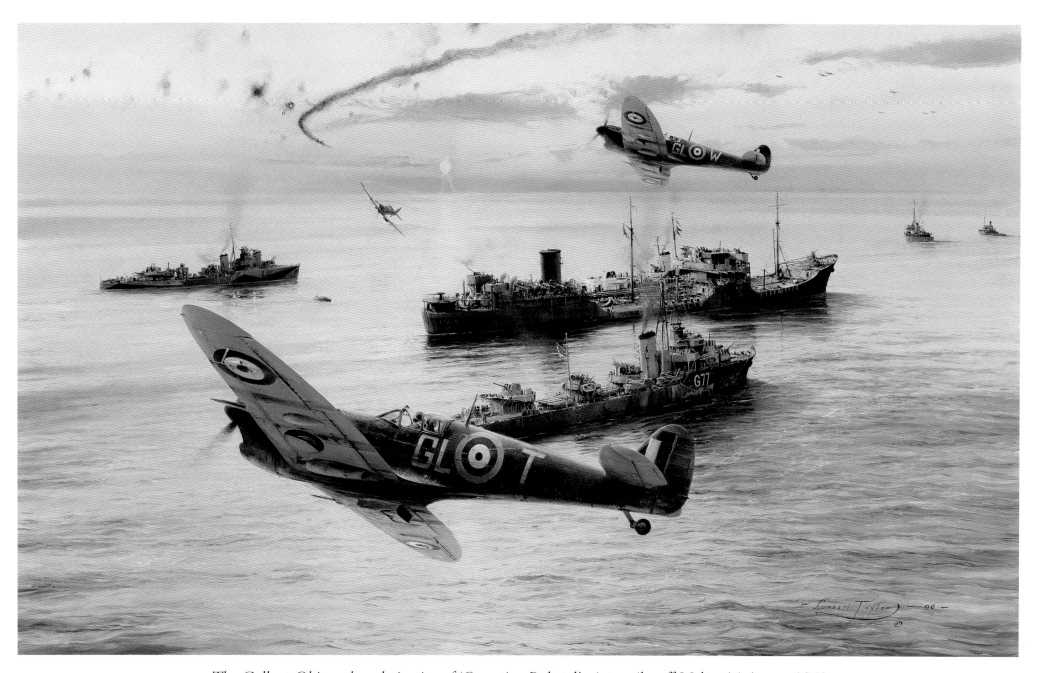

The Gallant Ohio – the culmination of 'Operation Pedestal', sixty miles off Malta, 14 August 1942

In the collection of Mr Edgar Leicher

'Remember Pearl Harbor!'
– Attack on the USS Nevada

When Imperial Japanese Navy aircraft made their devastating attack on the United States' Pacific Fleet at Pearl Harbor on the morning of 7 December 1941, in the words of Japanese Commander-in-Chief Admiral Yamamoto, 'I fear all we have done is to awaken a sleeping giant, and fill him with a terrible resolve'. In the four years that followed, driven forward beneath the emotive banner 'Remember Pearl Harbor!', American forces inexorably drove the Japanese from the Pacific.

The USS Arizona steadily steams towards the open sea. Pearl Harbor – '41

On that fateful December morning, as the Pacific Fleet lay peacefully at anchor, Japanese torpedo and dive-bombers from six carriers made their devastating attack on Pearl Harbor. Within ninety minutes they had destroyed or seriously damaged eighteen ships, leaving the dockyards in ruin. Among the casualties were eight battleships, including the USS *Arizona:* of her complement of 1,500 men only 300 survived. The infamous attack brought the United States into World War II.

Battleship Row

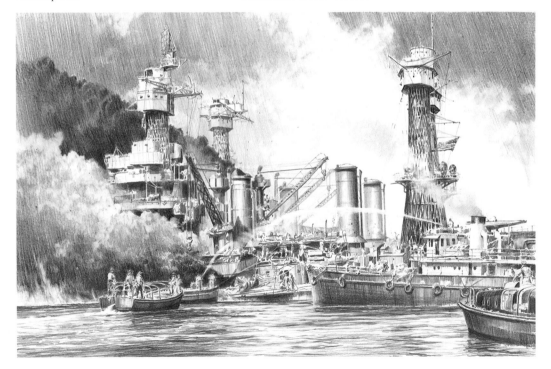

The USS *Nevada*, moored by herself, escaped the initial onslaught. However an enemy bomber, sighting the battleship as she got up steam, laid a torpedo into her, blowing a massive hole near the bow. With her forward compartments flooded, amid all the explosions, smoke and confusion, she gallantly steamed for the open sea.

Moving towards the main channel she was spotted by more bombers, who immediately attacked. The water around the ship erupted in a series of massive explosions. On fire, and with gaping holes all along her hull, *Nevada* was in danger of sinking. Fearing the worst, she manoeuvred her bow onto the beach at Hospital Point. At that moment the second wave of attack came in.

The raid on Pearl Harbor has been painted many times, and hundreds of photographs have been published showing the aftermath of the attack. I was looking for a new angle, and when I read the account of the attack on the USS *Nevada* I was inspired by the valiant efforts made to save her. Also, because most images show the events from the ground, I decided I wanted to position myself in the air for this painting.

The action is viewed at around 0900 hours during the second wave of attacks as dive-bombers make their final attempt to destroy the *Nevada*. In the dock behind, the destroyer *Shaw* is on fire; moments later she will explode. Behind her, in the swirling palls of dense smoke that pervaded the naval yard, are the battleship *Pennsylvania*, the cruiser *Helena*, and the Base Force flagship *Argonne*.

Though badly damaged, the *Nevada* survived the attack, was repaired, modernised, and sailed back into action in 1943.

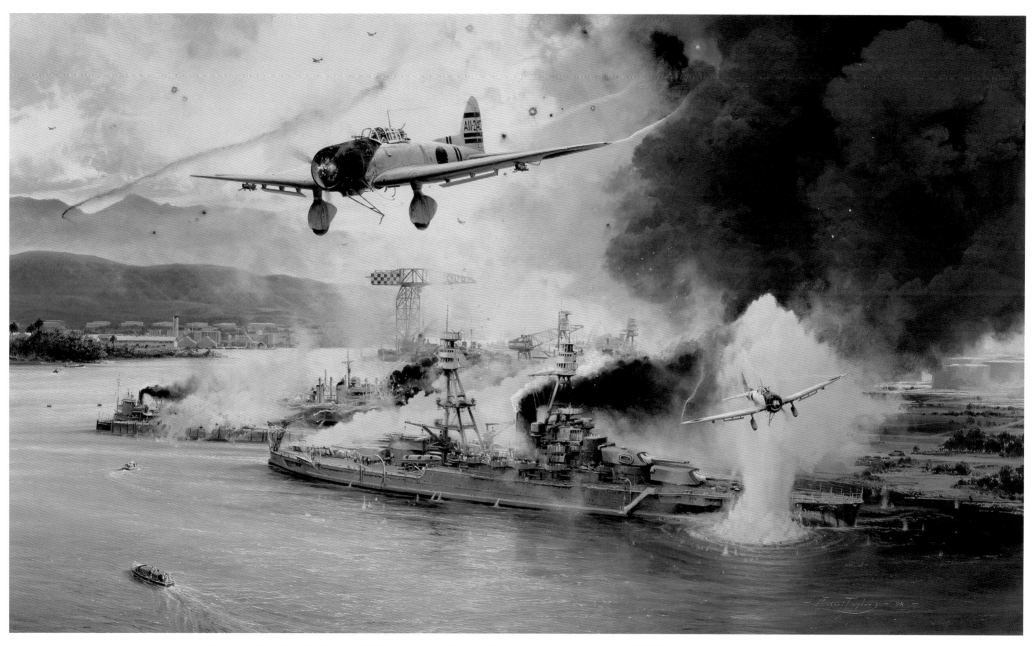

'Remember Pearl Harbor!' The scene at Pearl Harbor as the battleship USS Nevada comes under attack

In the collection of Mr Eugene Eisenberg

Night Attack in the Eastern Mediterranean

During the night of 15 June 1942 German E-boats of the 3rd Flotilla left their Eastern Mediterranean base at Derna to intercept an allied convoy bound for the island of Malta.

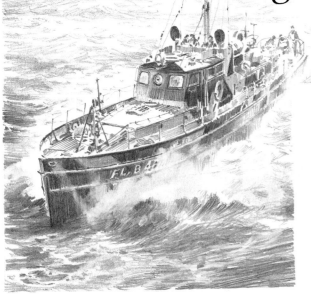

"Raūmboot".

Gathering accurate reference for paintings depicting actual events – as defined from generic paintings – is usually painstaking, and time-consuming. It is rare to obtain eyewitness accounts that have been carefully logged in detail, but in the preparation of this painting I was lucky.

I was commissioned by one of my greatest supporters, Edgar Leicher, to portray the attack on the British cruiser by the motor torpedo E-boat S-56, which took place shortly after midnight. S-56 had been under the command of Leutnant Siegfried Wuppermann, and I was fortunate to be given access to his personal diagrams and notes which detailed the attack from start to finish.

Approaching HMS *Newcastle* from astern, S-56 bypassed the two escort destroyers steaming off the cruiser's starboard side, and closed to within 600 metres. Suddenly a searchlight at *Newcastle's* foremast switched on, illuminating S-56 from stem to stern. Reacting quickly, Wuppermann fired two torpedoes at *Newcastle,* and turned hard to starboard to make good her escape. A second searchlight on board

Newcastle pinpointed S-56, but by then it was too late.

The painting shows S-56 some thirty seconds after the release of her torpedoes, at the moment the first one explodes against the hull of HMS *Newcastle.* The second will strike a few seconds later.

Travelling at 33 knots, under fire from the escort, S-56 threw out a smokescreen and released a depth charge as distraction, and made good her escape into the darkness. *Newcastle,* though badly damaged, managed to limp back to Alexandria.

The painting at below left portrays another incident which took place in 1942. On 29 March, the German Navy's 8th Flotilla, seeking to intercept convoy PQ13 off the Norwegian coast, were themselves intercepted by the escort screen. Destroyer *Z-26* received severe damage from the guns of HMS *Trinidad.* In deteriorating weather, *Z-25* proceeded with great seamanship to rescue *Z-26* survivors. The painting on the right shows the destroyers *Paul Jacobi, Theodor Riedel* and *Hermann Schoemann* passing through the Straits of Gibraltar, bound for Ceuta in October 1938.

The rescue of survivors from destroyer Z-26, 29 March 1942

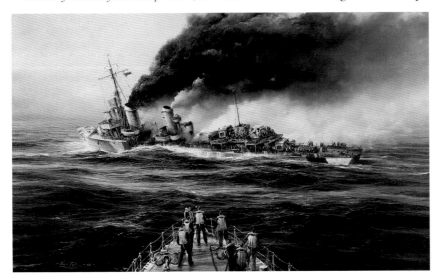

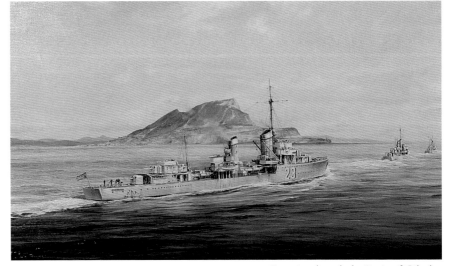

Steaming through the Straits of Gibraltar

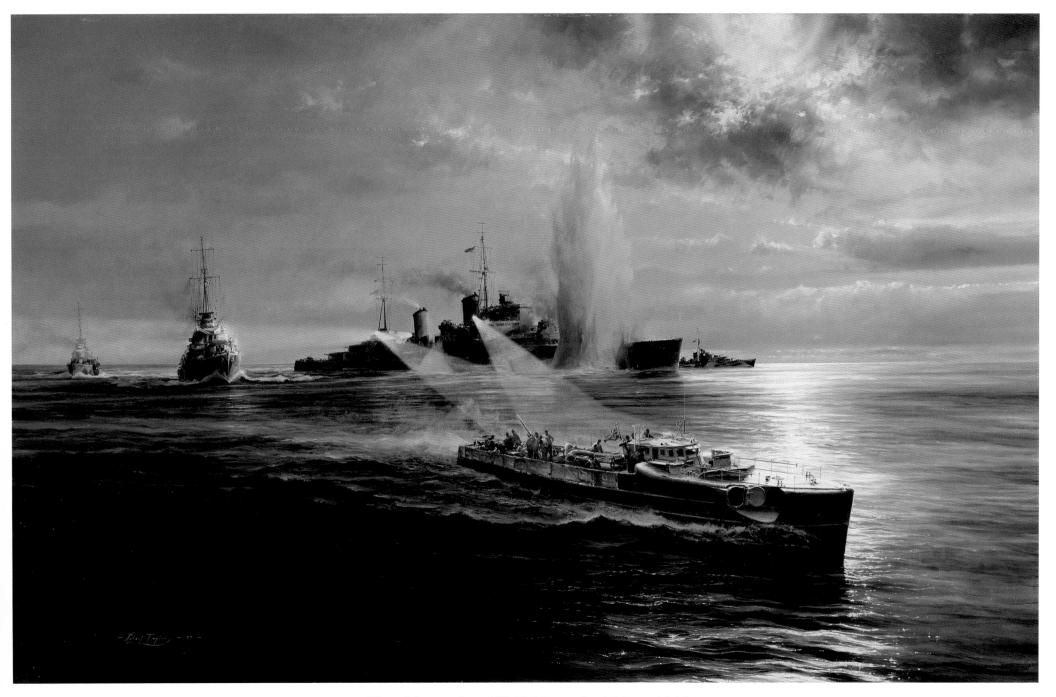

The night attack on HMS Newcastle, 15 June 1942

In the collection of Mr Edgar Leicher

The Channel Dash

Secrecy, careful planning, and the element of surprise, combined with a slice of luck, are the ingredients of success in war. Operation 'Cerberus', codename for the daring breakout of the German battle fleet from Brest in February 1942, contained all of these elements, resulting in one of the great maritime adventures of World War II.

The idea that Germany's principal capital ships, together with a large naval escort, could slip through the narrow, heavily defended straits of the English Channel, and pass within a few miles of the English coast without detection, seems preposterous. But they did, and before the Allies fully realised what was happening, the German ships were in the relative safety of the Elbe estuary.

This plate shows a detail from my interpretation of that famous Channel Dash. In the company of a flotilla of naval escort vessels, the fleet is led by *Scharnhorst,* followed by the *Gneisenau,* with the *Prinz Eugen* steaming up behind, as they round the tip of the Cherbourg Peninsula at dawn on 12 February 1942. The entire painting, which includes the fighter escort aircraft, is shown below.

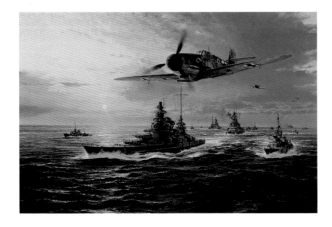

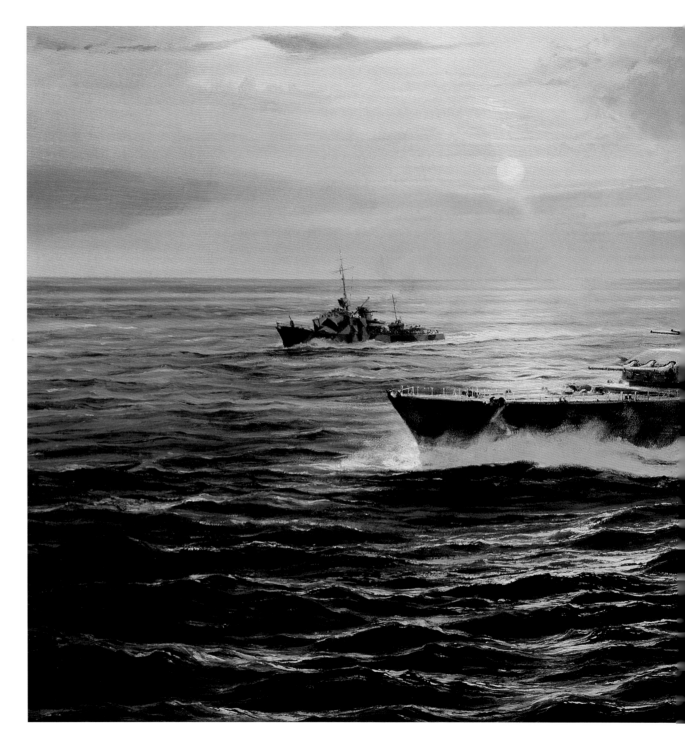

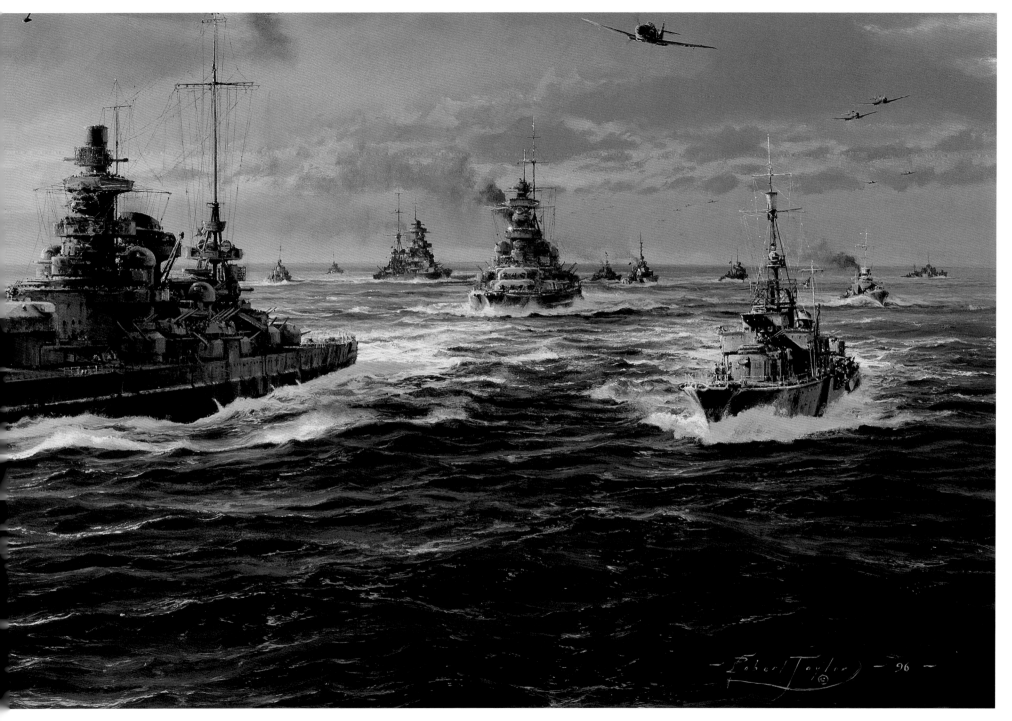

The Channel Dash – the breakout from Brest, 12 February 1942

In the collection of Mr Edgar Leicher

The Majestic Cruisers

How the sight of a cruiser majestically lying at anchor set the pulses of an eight-year-old boy racing,
and determined a career in the Royal Navy!

British Battleship Howe , East Indies Fleet 45.

HMS Cleopatra showing the flag

I have always felt a need to understand fully any subject I am going to paint, even in advance of attempting the preliminary drawings. This usually presents me with problems, since most of the subjects I paint are re-creations from the past. However, for a painting to stand any chance of conveying a sense of reality, I believe it is important for the artist to fully appreciate how the subject really is, or, more precisely in my case, how it was.

Painting ships that no longer exist always means plenty of research. Studying books, building accurate models, looking at photographs and old drawings, etchings and paintings are all useful, but there is no substitute for clambering all over the real thing. In the case of *Belfast* I have had that rare opportunity.

HMS *Belfast* lies on the River Thames at Tower Bridge in the pool of London. She will soon become the only British World War II warship built before the war to endure into the next millennium. Beautifully maintained as a museum ship, she is a living monument to the ships of the Royal Navy and the men who fought in them.

It is impossible to wander all over this wartime cruiser, as I have done many times, without becoming absorbed in her history. At the outbreak of World War II, *Belfast* had already joined the Home Fleet operating out of Scapa Flow. Patrolling north of the Faeroes in October 1939 she came across and captured the German liner *Cap Norte*. This success was shortlived, however, when she struck a mine, the explosion breaking her back.

After extensive repairs and modernisation, by 1942 she was the best-equipped cruiser afloat, operating on Russian convoys and offensives in northern waters. She took part in the destruction of the German battleship *Scharnhorst* during the Battle of North Cape in 1943, and later played an important role in the Normandy Landings of June 1944. HMS *Belfast's* distinguished naval career ended in March 1971. My painting shows *Belfast* steaming out of Scapa Flow in 1943.

The painting on this page shows HMS *Cleopatra*, another cruiser to see wartime service. Completed later than *Belfast*, HMS *Cleopatra* joined the 15th Cruiser Squadron in the Mediterranean in 1942. In the picture HMS *Cleopatra* is moored off Hastings on the south coast of England during a 'Show the Flag' visit after the war. The sight of this great cruiser made such a lasting impression upon an eight-year-old boy, Ian Menzies that, when he became old enough, he joined the Royal Navy. Following retirement after a career that took him all over the world, Ian commissioned this painting. You can just see the eight-year-old with his father in the forward part of the small pleasure boat!

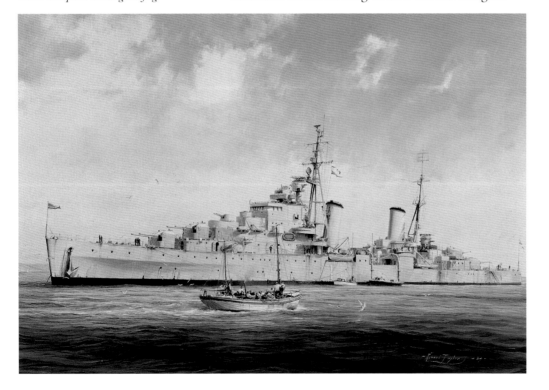

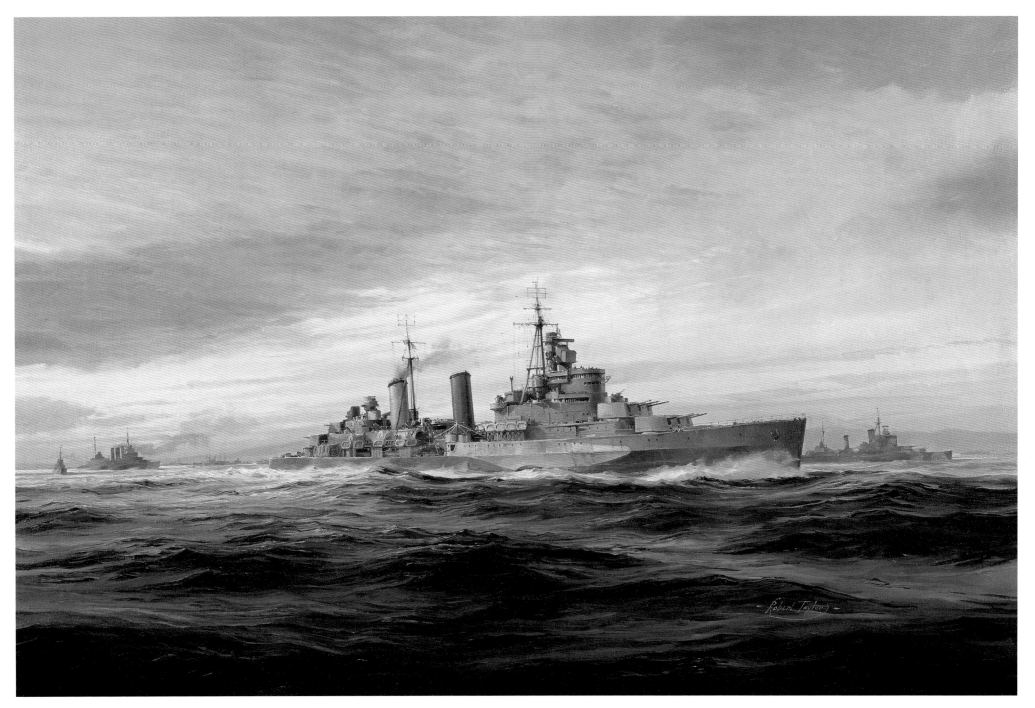

HMS Belfast departing Scapa Flow, 1943

In the collection of Mr Keith Wilson

Mission Beyond Darkness

The great naval battles fought across the vast expanses of the Pacific during World War II were dominated by carrier-borne aircraft. Planes have become the primary strike force of the world's sea powers ever since.

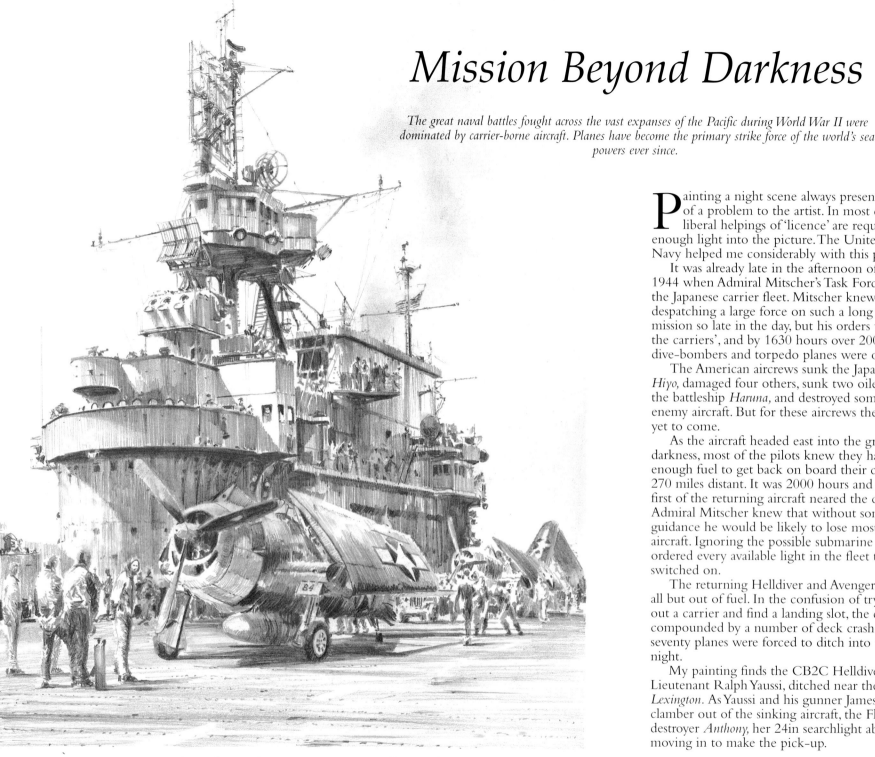

Preparing F6F Hellcats on the flight deck of CV-6 Enterprise. 44.

Painting a night scene always presents something of a problem to the artist. In most cases fairly liberal helpings of 'licence' are required to get enough light into the picture. The United States Navy helped me considerably with this painting.

It was already late in the afternoon of 20 June 1944 when Admiral Mitscher's Task Force 58 located the Japanese carrier fleet. Mitscher knew the risk of despatching a large force on such a long range mission so late in the day, but his orders were to 'Get the carriers', and by 1630 hours over 200 fighters, dive-bombers and torpedo planes were on their way.

The American aircrews sunk the Japanese carrier *Hiyo,* damaged four others, sunk two oilers, damaged the battleship *Haruna,* and destroyed some forty enemy aircraft. But for these aircrews the worst was yet to come.

As the aircraft headed east into the growing darkness, most of the pilots knew they had barely enough fuel to get back on board their carriers some 270 miles distant. It was 2000 hours and dark as the first of the returning aircraft neared the carrier fleet. Admiral Mitscher knew that without some form of guidance he would be likely to lose most of his aircraft. Ignoring the possible submarine threat he ordered every available light in the fleet to be switched on.

The returning Helldiver and Avenger pilots were all but out of fuel. In the confusion of trying to pick out a carrier and find a landing slot, the difficulty compounded by a number of deck crashes, some seventy planes were forced to ditch into the sea that night.

My painting finds the CB2C Helldiver of Lieutenant Ralph Yaussi, ditched near the carrier *Lexington.* As Yaussi and his gunner James Curry clamber out of the sinking aircraft, the Fletcher Class destroyer *Anthony,* her 24in searchlight ablaze, is moving in to make the pick-up.

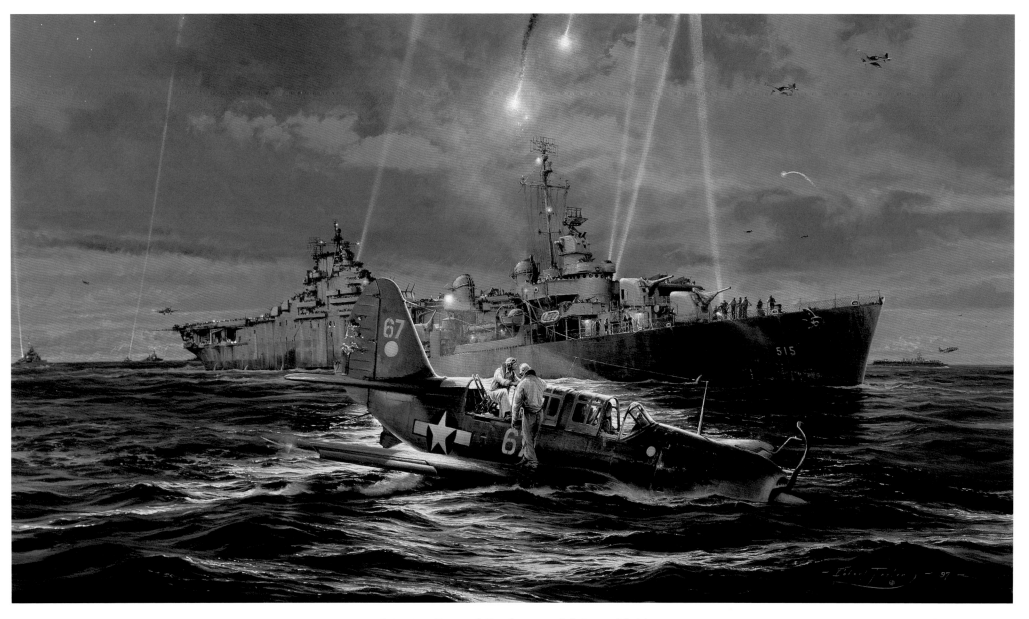

Mission Beyond Darkness – 20 June 1944

In the collection of Mr Eugene Eisenberg

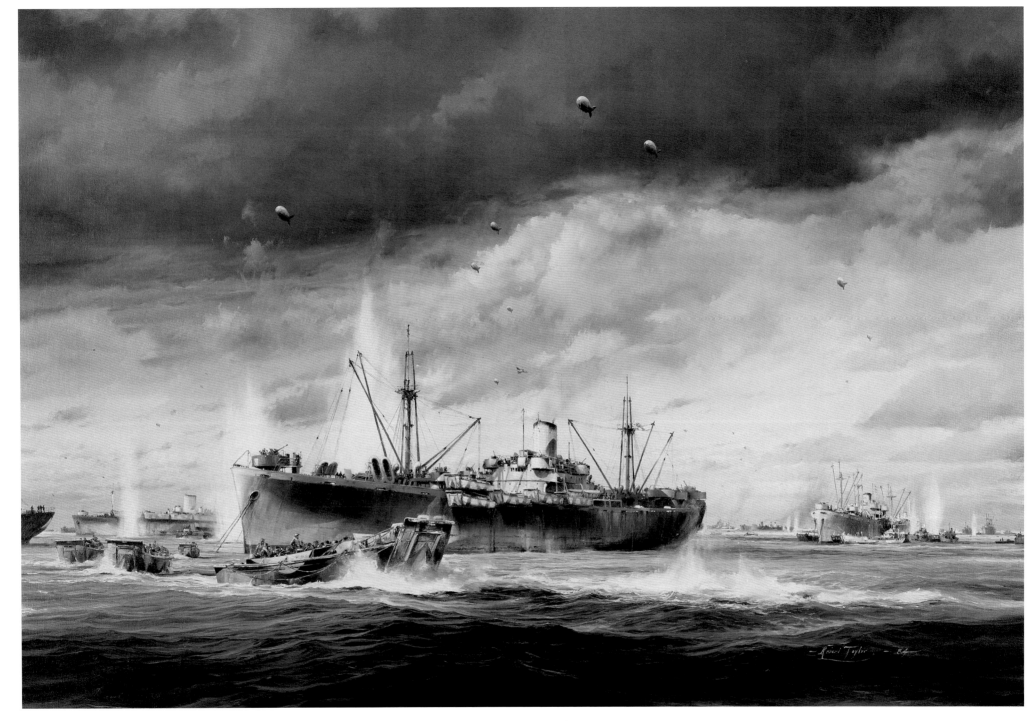

D-DAY – The Normandy Landings, 6 June 1944

In the collection of Mr Eugene Eisenberg

D-Day – The Normandy Landings

On 6 June 1944, warships, merchant ships, landing craft, and almost every conceivable type of ancillary marine vessel capable of ferrying men and machines made up the greatest maritime invasion force in history.

D-DAY – detail

Somewhere approaching 7,000 craft, comprising almost every type of vessel imaginable, crossed the English Channel to land troops and machinery on the beaches. It is difficult to envisage a situation where so many boats might ever be assembled together again.

The majority of troops were ferried across the Channel in American-built Liberty ships, transferring to the landing craft for the last mile or so for the run ashore. The sea was unusually rough and many troops, unused to being tossed around in a boat, were feeling distinctly uncomfortable long before they hit the beaches. One veteran said he was so seasick he almost preferred to face bullets on the beach than spend another moment in the relative safety of the heaving boat!

Anchored offshore while they disgorged their cargoes, the Liberty ships were sitting targets. Some raised barrage balloons to deter attack from the air, but when it was realised these were being used by enemy shore batteries to calculate accurately the range, they were hastily lowered.

Because the morning of D-Day was dull and overcast, I'd thought about brightening up the painting with a little sunshine, but reckoned I wouldn't get away with it! Many years later I mentioned this to Eugene Eisenberg, who owns the painting. 'Just as well,' he said. 'I wouldn't have wanted the painting if you had.' He is a major collector of original paintings and, like others who collect military art, is a stickler for accuracy!

I have shown a hectic scene during the early stages of the landings in the morning, with shells exploding among the landing craft as they pull away, heading for the beaches. The barrage balloons were hauled down a few minutes later!

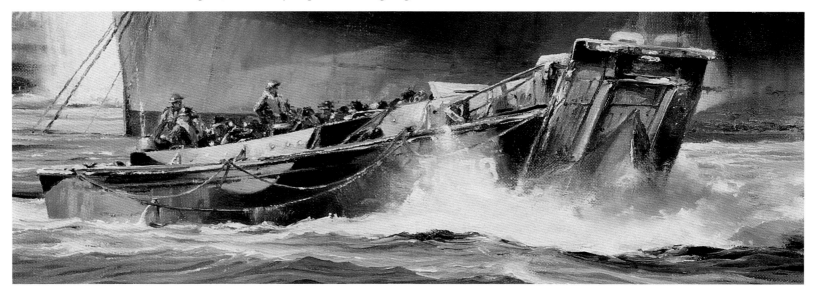

War In The Atlantic

The U-boat wolf packs roamed the vast expanses of the oceans with impunity until aircraft became available with sufficient range to intercept them.

South Atlantic May 1941
Supply Tanker 'Nordmark' camouflaged as US Prairie.

All four Commanders: Schütze, Heßler, Metzler and Eckermann survived the war - whereas the U. Boats U103, U107, U69 and UA were all lost under other commanders.

*A*gainst *All Odds* was painted specifically to be reproduced as a limited edition, with each of the prints to be signed by no fewer than nine ex-U-boat men, all of whom had been decorated with the Knight's Cross. One, Erich Topp, was credited as being the third most successful U-boat captain of the war, and with all these distinguished submariners about to scrutinise my painting I had to think carefully about the composition.

Atlantic Rendezvous

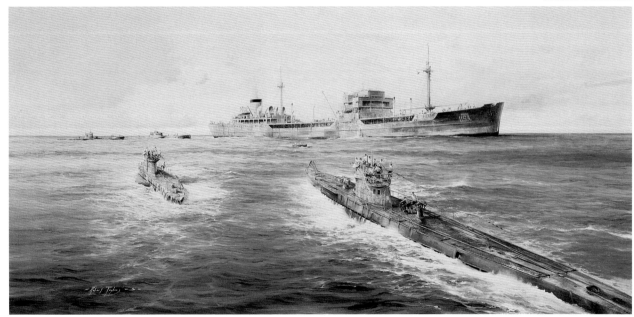

To my way of thinking, the only way to paint a submarine is for it to be on the surface. Though these craft conduct most of their business underwater and of course, it is possible to compose an underwater scene, in reality this would produce a fairly colourless canvas in monotone blue. So I chose a scene that happened more often as the war progressed – a U-boat under attack from the air.

The scene here shows a type VIIc U-boat off the Straits of Gibraltar in 1944. Caught on the surface by an American PBY Catalina of the Fleet Air Wing based at Port Lyautey in French Morocco, the U-boat gun crews move quickly into action. The 37mm anti-aircraft gun is hurriedly reloaded while on the upper platform the two 20mm anti-aircraft twins take chunks out of the Catalina's tail – enough damage, the crew will be hoping, to secure a respite from the attack, and allow the submarine to dive to relative safety beneath the Atlantic swell. The painting was one of the few that went well from start to finish, and I was very happy with the outcome. Fortunately for me, so were the ex-submariners from the Kreigsmarine!

The painting on this page, *Atlantic Rendezvous*, tells an interesting story of German deception. The supply tanker *Nordmark* has been cleverly disguised as the American tanker *Prairie*, flying the American flag and prominently displaying the letters 'USA' on her bows. A clutch of U-boats converges on the German tanker to take on board fuel, food, ammunition and medicine.

Is it not said that all is fair in love and war?

66

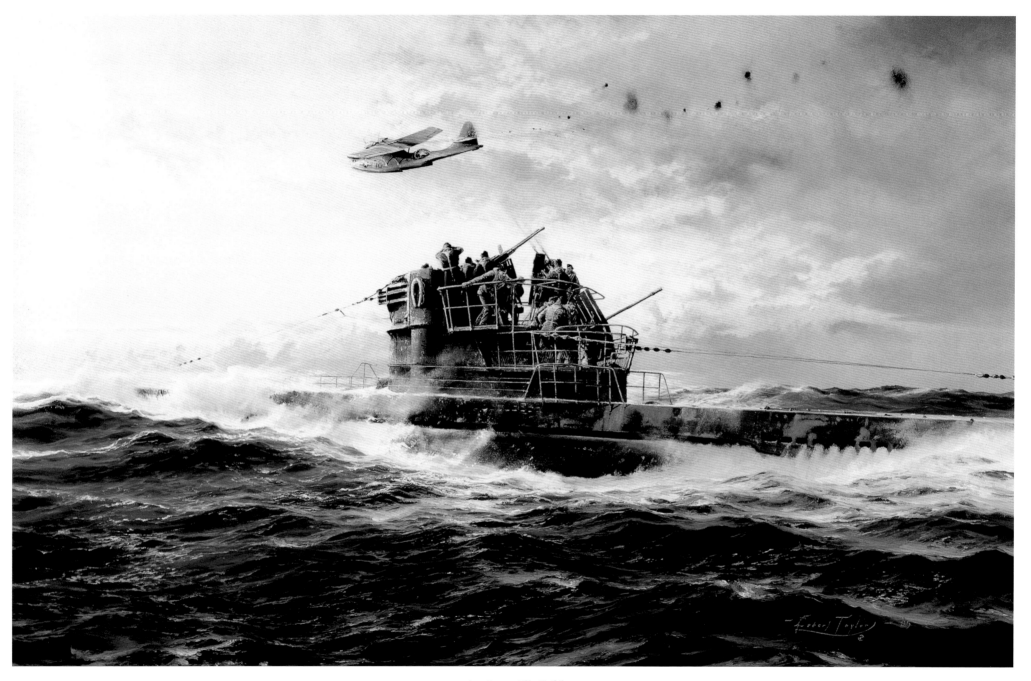

Against All Odds

In the collection of Mr Edgar Leicher

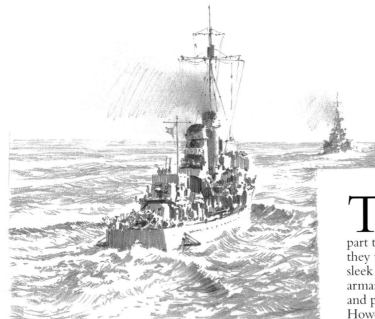

The Era of the Battleships

During the first half of the twentieth century battleships, the most impressive of all warships, had their day. With Admirals striding their bridges, these great flagships were the pride of every Navy, and the very mention of their names put fear into the hearts of their enemies on the high seas.

The era of the great battleships has passed into history. Whatever emotions are aroused by the memory of these mighty fighting ships and the part they played in World War II, nobody will deny they were a magnificent sight under way. With long sleek hulls, their superstructures bristling with armament, these huge ships packed massive firepower and posed a fearsome threat whenever they put to sea. However, with the rising power of the aircraft carrier, it became evident early in the war that battleships were vulnerable to attacks from the air, and that their days as the fleet flagships were numbered.

One of the most impressive and famous ships in the German Navy was the battle-cruiser *Prinz Eugen*. She took part in the sinking of the *Hood,* and later in

the famous Channel Dash. Here I painted her on operations in the Baltic, her main turrets firing a broadside at Russian positions ashore, in January 1945. To add further interest to the composition I viewed the scene from the bridge of destroyer *Z-25*.

Prinz Eugen survived the war, surrendering at Copenhagen, following which she was taken to the Pacific atoll of Bikini. There she met an inauspicious end as part of the atomic bomb tests.

The picture below shows a detail from a commission depicting a scene from 'Operation Cerberus', when the battle-cruisers *Scharnhorst, Gneisenau* and *Prinz Eugen* made their spectacular and successful dash through the English Channel on 12 February 1942. The *Scharnhorst* is seen taking the lead.

Operation Cerberus – detail

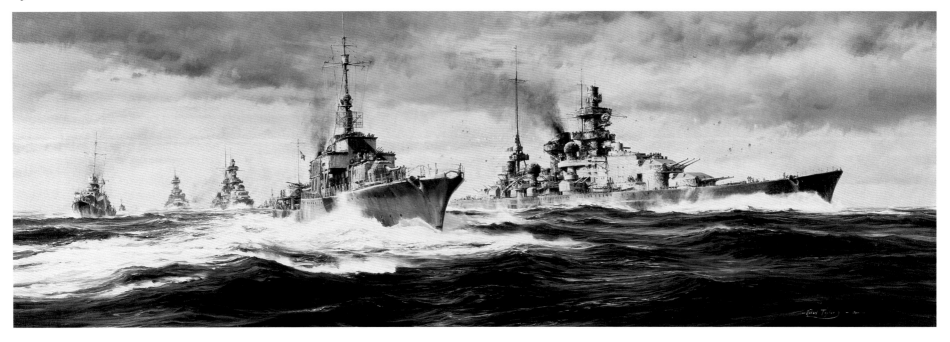

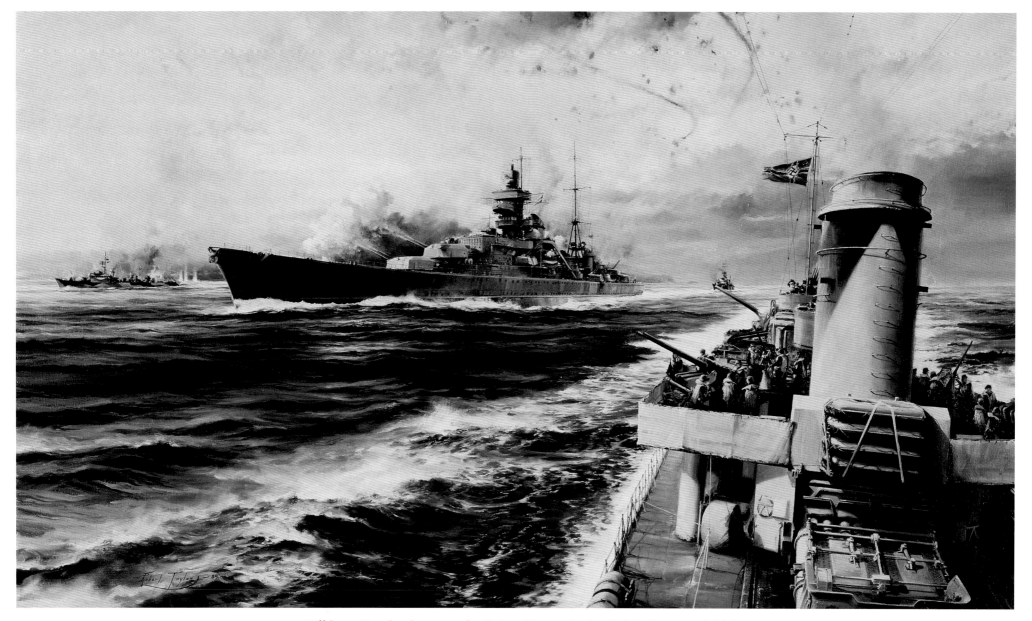

Offshore Bombardment – the Prinz Eugen in the Baltic, January 1945

In the collection of Mr Edgar Leicher

HMS Vanguard

No fewer than nine Royal Navy warships have carried the name Vanguard, *the first dating back to a 32-gun galleon that helped fight off the Spanish Armada in 1588. The last brought to an end the era of the great battleships.*

'Triumph' Flagship of the 3rd Carrier Squadron, Med.

The frigate HMS Loch Alvie

The most famous *Vanguard,* and the fifth to be so named, was Nelson's flagship at the Battle of the Nile in 1798, a 74-gun ship built at Deptford in 1787. The tradition was carried forward, the eighth *Vanguard* being a 19,000-ton dreadnought which took part in the Battle of Jutland in 1916. She came to a sticky end when she blew up in Scapa Flow as a result of her magazines becoming overheated.

The last of the line, a mighty 44,000-ton battleship, was launched in 1944 but not completed until the year after the end of World War II. Something of a hybrid, her massive 15in guns originally belonged to *Courageous* and *Glorious,* having been removed when these two ships were converted to aircraft carriers between the wars. Nevertheless the new HMS *Vanguard* had attractive, rakish lines and proved to be the finest sea boat of all the battleships. But she never saw action.

She had the honour of taking King George V and Queen Elizabeth, now the Queen Mother, on the Royal Tour to South Africa in 1947. My good friend, the late Group Captain Peter Townsend, was equerry to the King on that trip. His 'inside' – and I hasten to add entirely discreet – accounts of some of the amusing and unreported events he experienced gave a fascinating insight into the machinations and politics involved during such a Royal Tour.

HMS *Vanguard* is probably best remembered for her part in the Coronation Review of the Fleet for the new Queen Elizabeth II at Spithead in 1953. Between 1956 and 1960 she was the flagship of the Reserve Fleet at Portsmouth when she was at the disposal of NATO, ending her peaceful life when she was towed to Faslane to be scrapped.

My painting was commissioned by the family of a retired naval commander who had served aboard HMS *Vanguard* and the painting was to be a surprise sixtieth birthday present. I recall working late many evenings to get the painting completed in time, and when I delivered it to a restaurant on the day of the party, the paint was still wet!

The painting on this page is another that was commissioned by an ex-Navy crew member of a ship held dear in the memory. HMS *Loch Alvie* was a frigate built in 1944. She operated with the 9th Canadian Escort Group on convoy duties and took part in the last convoy of the war to north Russia. *Loch Alvie* was decommissioned in 1963.

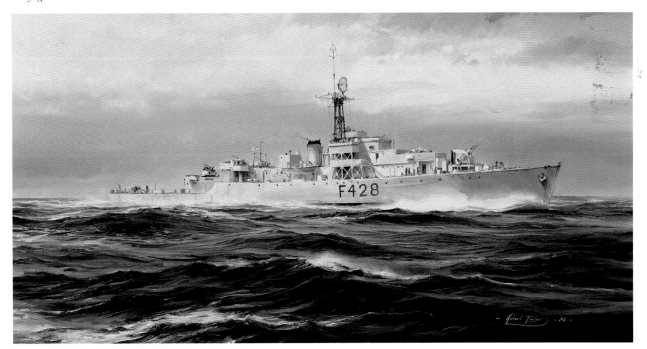

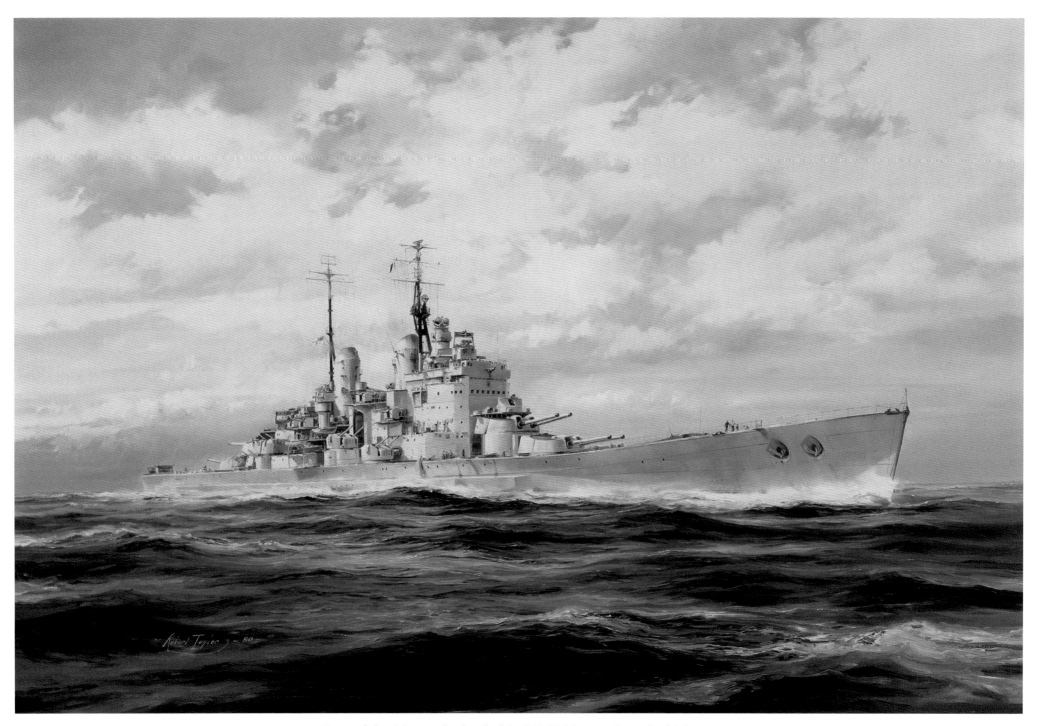

Last of the Line – the battleship HMS Vanguard on the high seas

Private collection

The Queen Mary

In the presence of King George V and the Prince of Wales – later to become King – Queen Mary launched one of the most opulent ocean-going liners ever built on 26 September 1934. RMS Queen Mary *was the first merchant ship ever to be launched by a reigning monarch.*

When the transatlantic liner *Queen Mary* retired to a berth at Long Beach, California in 1967, she brought to an end an era of maritime opulence, romance, and glittering extravagance. In her day she carried over two million voyagers on lavish Atlantic crossings. Her passenger lists were studded with royalty, world leaders, stars of the silver screen and the rich and famous.

Making crossings in under four days, she held the coveted Blue Riband for fourteen years. When war broke out her 30-knot speed enabled her to cross with troops in relative safety without protection from escort or convoy. After the war she resumed her role playing host to the world's high society, but by the late 1960s jet air travel signalled the end of shipboard opulence and grandeur.

In 1988, with my wife Mary, I visited this great ship at Long Beach, and by just walking around it, it was easy to imagine the romance of those great transatlantic crossings. My painting sets the scene with the *Queen Mary* departing New York in the early post-war period, her decks lined with passengers as the great liner points her bows eagerly towards the Atlantic.

The Queen Mary about to pass the Queen Elizabeth
in mid Atlantic

Farewell America – RMS Queen Mary departs New York for Europe

In the collection of Mr Eugene Eisenberg

The Falklands War

When Argentina invaded the Falkland Islands in 1982, Prime Minister Margaret Thatcher despatched a huge task force to the South Atlantic. As the massive fleet departed British shores it was given a rousing send-off, and a wave of patriotism swept the country.

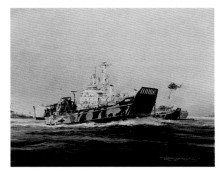

Landing craft at San Carlos Bay

Sea King Rescue – SS Atlantic Conveyor

Such was the scale of the operation almost everyone had friends or relations on those ships, and as the fleet approached the war zone the constant television newscasts increased the anxiety of the nation. I knew a number of the Sea Harrier pilots embarked on the carriers *Hermes* and *Invincible,* one of whom was a good friend, Commander Nigel Ward. Known as 'Sharkey' throughout the Fleet Air Arm, he had the responsibility of moulding the Navy's Sea Harriers into a front-line fighting force, and when they arrived in the battle zone, leading them into combat. The well documented outcome of the war is history.

After the war I was commissioned to complete several paintings for the Fleet Air Museum, and 'Sharkey', who had returned with three air victories and a DSC to his credit, was a prime source of my information. The first of these paintings was to feature Rear Admiral 'Sandy' Woodward's flagship, the carrier HMS *Hermes,* leading the task force as it approached the battle zone.

In order to show as many ships as possible I elevated my view somewhat, as can be seen in the main painting to the right. This complicated the perspective considerably, but enabled me to include seven ships in the composition. They are, from left to right, in the background the County Class cruiser *Glamorgan,* the Type 21 frigate *Ardent,* the Fleet Auxiliary Tanker *Olna,* and the Fleet Replenishment ship *Resource.* In the foreground is another Type 21 frigate *Arrow,* and to the right of *Hermes* the Type 42 destroyer *Sheffield.* Both *Ardent* and *Sheffield* were lost in action during the war.

Among the paintings for the museum was one featuring HRH Prince Andrew piloting his Sea King helicopter while evacuating survivors from the SS *Atlantic Conveyor* following an Exocet missile strike. Prince Andrew and his crew were first on the scene, and the painting at bottom left shows his Sea King having just lifted off the deck of the burning ship.

I had the honour and the privileged experience of being invited to Buckingham Palace, where the Prince cast an expert eye over the painting. This resulted in one important alteration to my work: I had painted a Lynx helicopter where I should have shown a Wessex, and Prince Andrew asked me to make the appropriate alteration. After a couple of other helpful comments, he gave the painting his blessing and we sat down to afternoon tea and an interesting discussion about art.

The painting at top left shows HMS *Fearless* launching her landing craft, heading for San Carlos Bay.

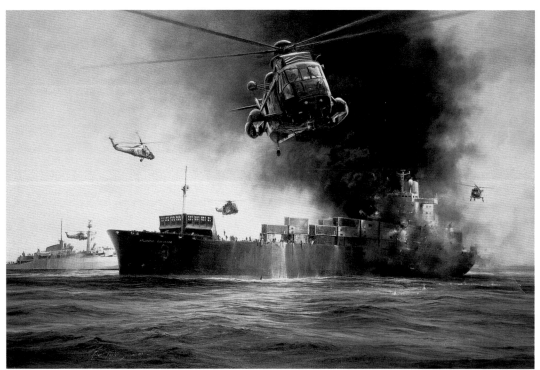

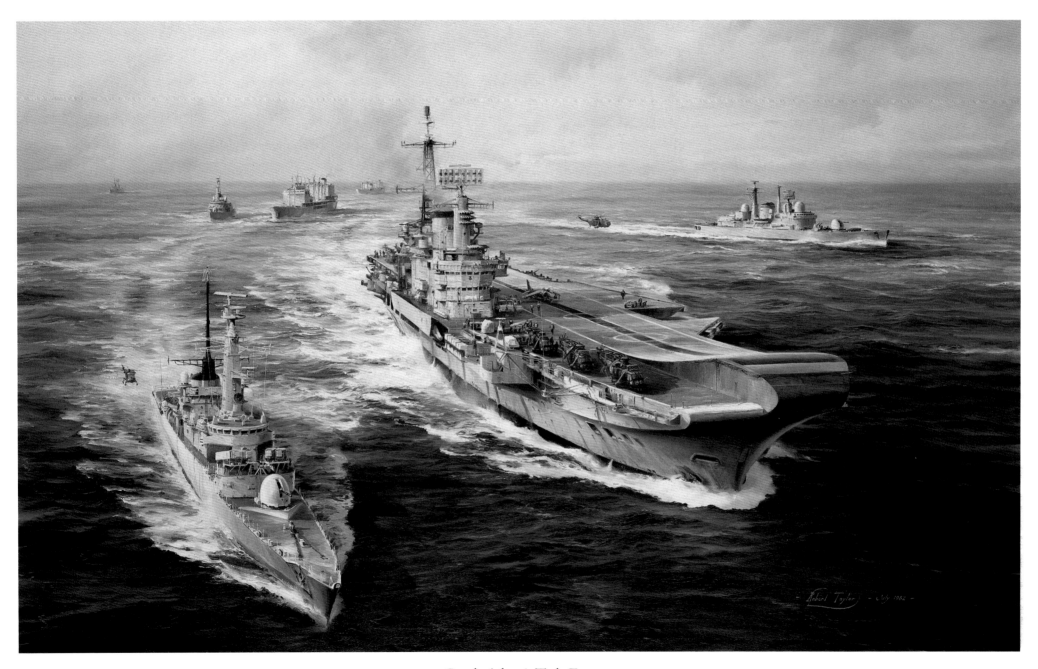

South Atlantic Task Force

In the collection of The Fleet Air Arm Museum

HMS York

The many experiences, and losses, in the Falklands Campaign brought about changes to the new ships under construction for the Royal Navy in the 1980s. HMS York, a Type 42 destroyer, when completed in 1985 became one of the new breeds.

I was commissioned to paint HMS *York* by Sir Donald Gosling whose wife, Lady Gosling, performed the launching ceremony for this latest addition to the Fleet. The painting was to be presented to the ship as a gift from Lady Gosling, and

HMS York on the Tyne, setting out for her sea trials, 13 August 1984

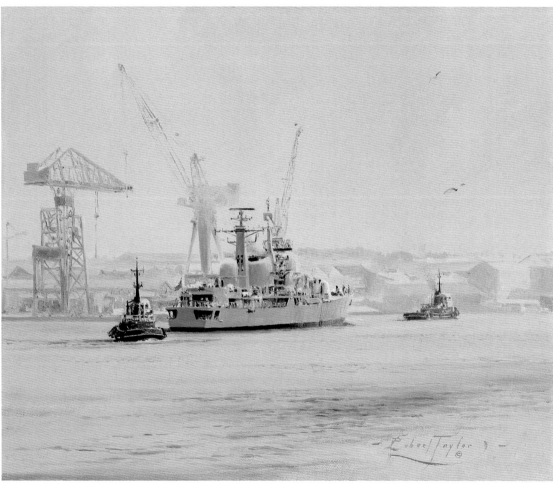

I believe it now hangs in the Ward Room aboard HMS *York*.

Sir Donald had arranged for me to visit the Swan Hunter shipyard where *York* was undergoing her final fitting out. I travelled up to Newcastle in August 1984 to get a good look at her. *York* was due to make her way down the Tyne later that morning to start her sea trials. So the Royal Navy, keeping rather different working hours from me, sent a young naval officer early the following morning to collect me from my hotel. It was a slightly bleary-eyed artist that arrived on the quayside at 5am in the morning!

As we arrived at the dock, the daybreak had brought with it one of those early morning mists that so often heralds a warm summer's day. As I looked up through the haze for the first time at *York*, with the sun doing its best to light her up, I recall the mist swirling around her superstructure giving the new ship a rather ghostly appearance. Even the figures moving about on board seemed like phantoms as they appeared and disappeared in the mist.

My brief was to paint *York* at sea, so the purpose of my trip was to familiarise myself with this new Type 42 destroyer, and make sure I knew exactly how she was fitted out above deck. Later, as she was eased from her berth by tugs and made her way down the Tyne towards the open sea, we all went down the river to the breakwater. We watched in silent awe as the Royal Navy's newest ship quietly disappeared into the mist that still hung over the North Sea.

The painting gives a good view of the 'stretched' Type 42: *York's* lengthened bow was one of the many modifications made during her construction, a feature which gave her that racy look. The oil sketch at left shows HMS *York* as she glides down the Tyne heading for the first time towards the open sea.

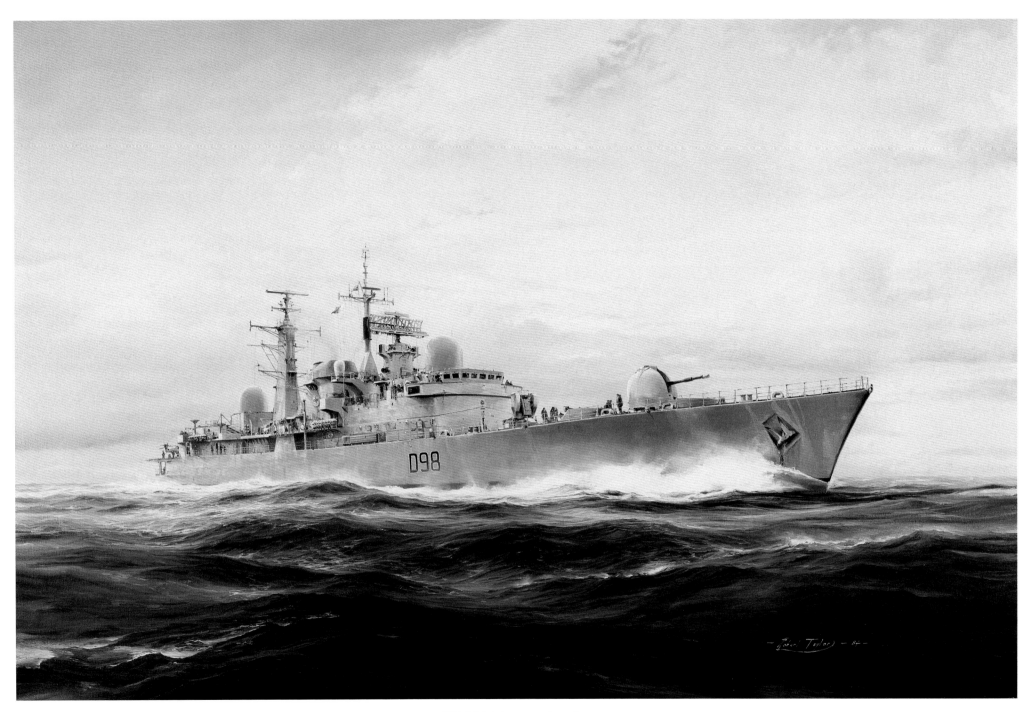

HMS York on active duty

In the collection of the Royal Navy

The Royal Yacht Britannia

For forty years she carried the British Royal Standard to the four corners of the world, hosting Kings and Queens, Emperors, Presidents, Prime Ministers, the rich and famous. The glamorous career of the most famous yacht afloat came to an end in 1998, and her glory days are now just a memory.

Britannia, Portsmouth 13-6-94.

Britannia – detail

Commissioned in the early 1950s, the Royal Yacht *Britannia* was built to an Admiralty design based on the well tried and successful, fast merchant passenger liners of the Harwich Ferry type. Carefully considered plans were laid so that *Britannia* could be conveniently converted to a hospital ship in times of war – a plan that was put into action during the Falklands War in 1982.

Not as extravagantly sumptuous as the craft of some of today's very wealthy yacht owners, the Royal Yacht *Britannia* was, as one would expect, beautifully and tastefully fitted out. Her hand-picked crew was of the highest calibre, trained to blend superlative seamanship with diplomacy and protocol.

I was commissioned to paint *Britannia* moored in the special place reserved for her on the River Thames just off Tower Point. Viewing her one cold February afternoon, just as I took up my position on the opposite bank of the river, the sun bathed the entire scene with a warm glow as if a spotlight had been turned on. With *Britannia* lying against the historic backdrop of the Tower of London and Tower Bridge, I could not have asked for a more perfect setting.

Below is a detail showing *Britannia* in all her glory. Today she is decommissioned but happily has been preserved as a museum ship, and rests at Leith docks in Edinburgh.

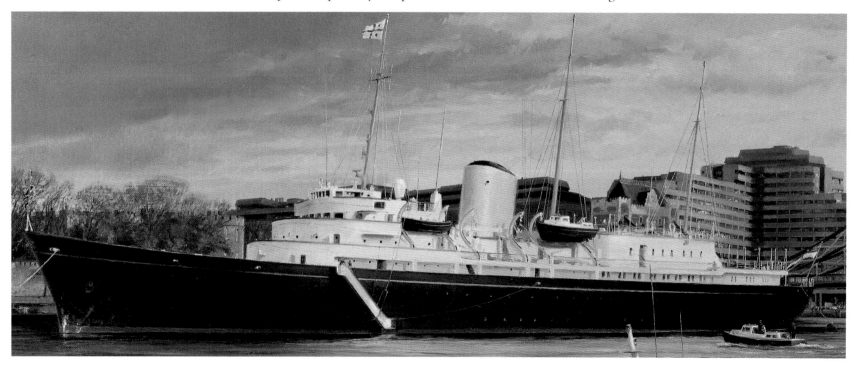

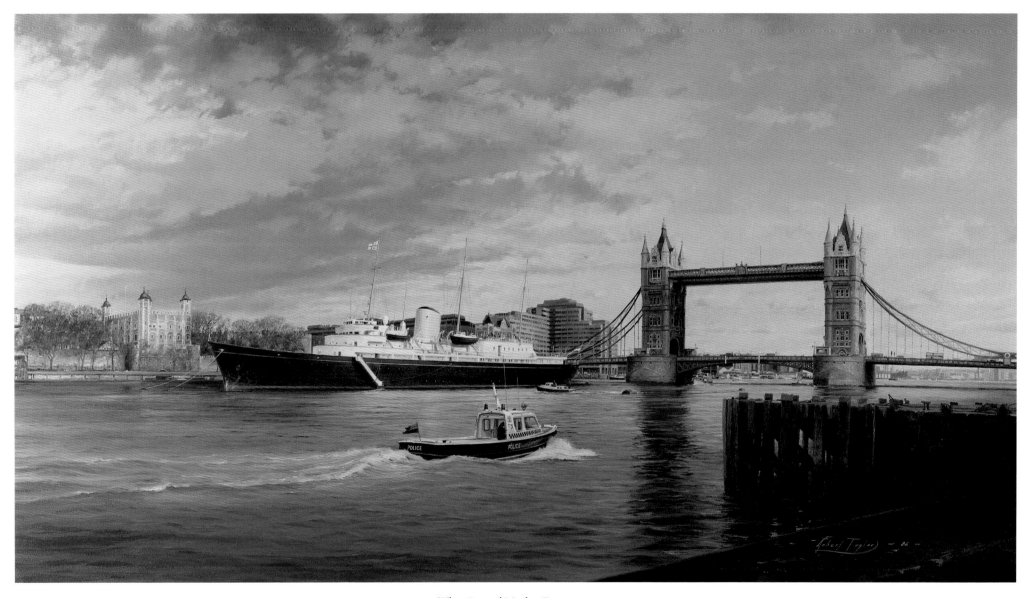

The Royal Yacht Britannia

In the collection of Sir Donald Gosling

Acknowledgements

From the time one sets about producing a book such as this to the day of publication takes about a year. To begin with, discussions are held with the publisher about the general concept and format, then design ideas are worked out, followed by preparation of visual layouts. Then the individual paintings and drawings are selected, and more design work is needed to position these in some sort of order that visually makes sense. Next the areas of text are allocated, and again this is by careful design, the aim being that each page when completed will appear pleasing to the eye.

When all this has been done, the text has to be written to a specified number of words so as to fit the page. All this material is then assembled and delivered to the publishers, together with large colour transparencies ready for scanning. We all then sit back for a breather while the printer scans, prepares film and printing plates.

When the colour proofs arrive, the production team huddles together to decide how these need to be colour-adjusted to match the paintings as closely as possible. This sometimes takes several shots over a period of several weeks. Finally we accept the proofs and the printer is left to complete the job. For the production team there is now a brief period of eager anticipation while we wait for the first bound copies of the book to arrive.

It is, for me, an intensely exciting moment when I open the new book for the first time. As I turn each page I am reminded of the huge contribution of all the dedicated people who have put so much effort into bringing the book together. For the most part the team is the same group who helped me with the preparation of my three previous volumes, and to all of these friends I am deeply grateful.

It is a great honour for me that the Rt. Hon. Sir Edward Heath has written the foreword. Former Prime Minister, Ted Heath has been one of Britain's most successful and determined post-war yachtsmen.

Incredibly just three years after taking his first sailing lesson, he was to win one of the world's most gruelling ocean races, the Sydney to Hobart. In 1971 he captained Britain's winning Admiral's Cup team.

I am indebted to Sir Edward for his contribution.

My special thanks to Michael Craig who so creatively designed the entire presentation of the book, and thoughtfully positioned all the illustrations and text, the result of which I believe nicely complements the art. Again, I am grateful to Rosie Craig who proof-read all the text, and made sure I haven't mixed up too many metaphors or split an unacceptable number of infinitives!

Pat Barnard again edited my text, co-ordinated the entire production, and this time also wrote the introduction. As ever, his help is so much appreciated. Stephanie Roberts-Morgan supervised the logistics, gathered together all the transparencies, and organised the photography of many paintings so ably captured by the Military Gallery's expert photographer, John King – my thanks to them. As always, a special vote of thanks to the splendid teams at the Military Gallery on both sides of the Atlantic, who publish all my prints and give me continual support year in, year out.

The staff at David & Charles have, as always, been brilliant. Nobody publishes a better range of art books featuring the works of contemporary artists, and they do us present-day artists proud. I am extremely grateful to them.

Most important of all, I would like to acknowledge all the wonderful people who collect my maritime paintings and prints. It is these people who have made this book, indeed my career, possible. To each and every one of you, I shall be eternally indebted.

Evening Surf